# Collector's Publication:
A SECRETE PUBLISHING COM
By

Vincenzo Peruggia

2017
New York, New York

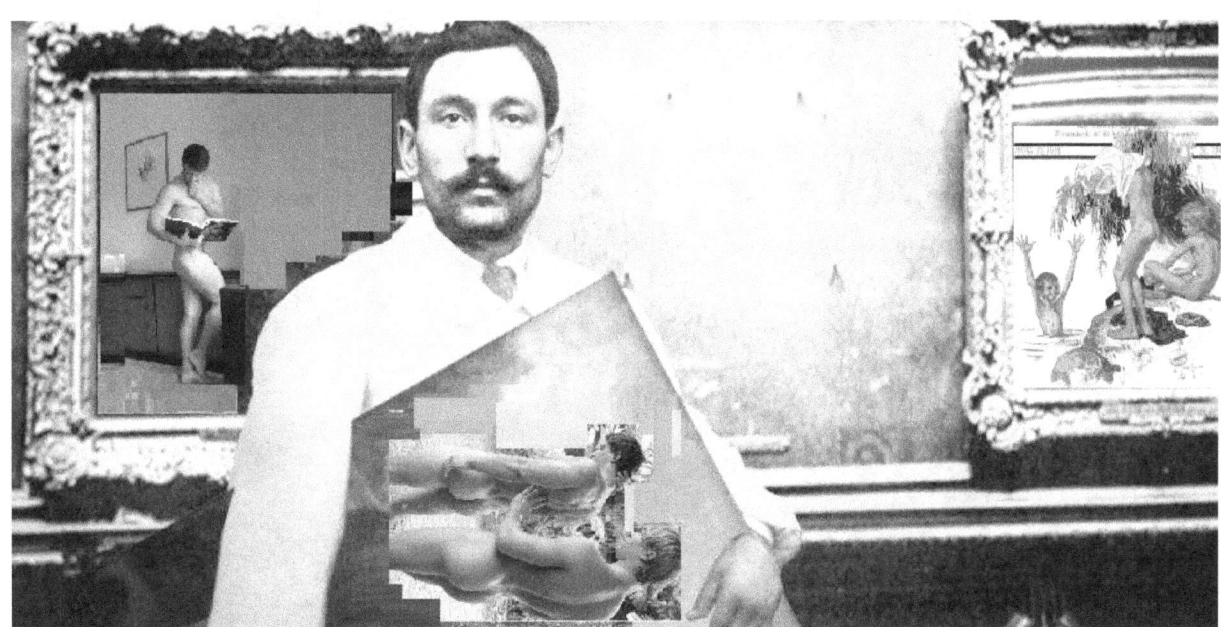

COLLECTORS PUBLICATION

# Collector's Publication: A SECRETE PUBLISHING COMPANY

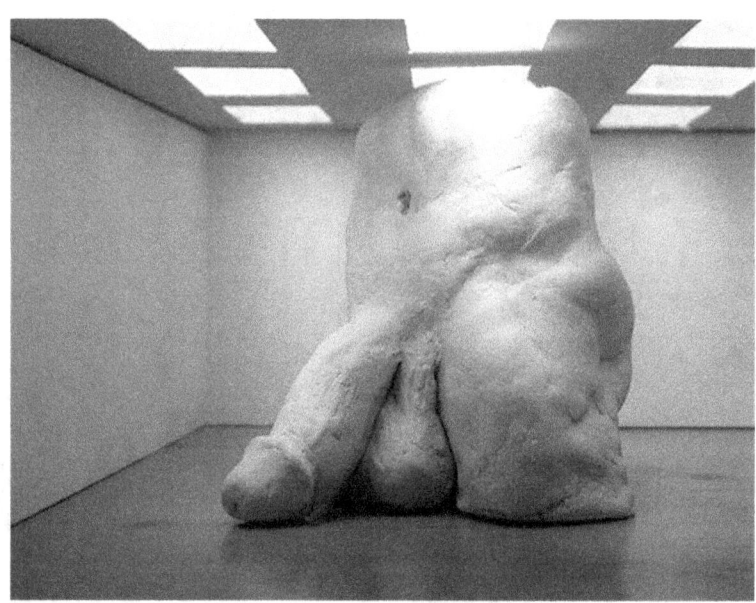

Book cover: by Homo-Erotic Studio.
Book cover designed by Katherine Manning and Thomas Campbell.

Copyright © 2017 by Homo-Erotic. Inc.
For permission requests, write to the publisher, addressed "Attention: Permissions Coordinator," at the address below.
Homo-Erotic.com
1233 Pennsylvania Avenue
San Francisco, CA 94909
www.homo-erotic.com
Ordering Information:
Quantity sales. Special discounts are available on quantity purchases by corporations, associations, and others. For details, contact the publisher at the address above.
Orders by U.S. trade bookstores and wholesalers. Please contact Big Distribution: Tel: (800) 800-8000; Fax: (800) 800-8001 or visit www.homo-erotic.com

## Introduction

Collector's Publication was a secrete publishing comany founded by Vincenzo Peruggia as a small studio at his home in Paris; a few hand-picked males posing for postcards that were sold to people who bought illegal art that could never be sold or viewed except in private museums. Vincenzo Peruggia passed his trade down to his three sons, and them to their sons, and so on.

Collectors Publications is the representation of sexual activity between males. Its primary goal is sexual arousal in its audience.

# Chapter 1

Vincenzo Peruggia (October 8, 1881 – October 8, 1925) was an Italian thief, most famous for stealing the Mona Lisa on 21 August 1911. Born in Dumenza, Varese, Italy, he died in Saint-Maur-des-Fossés, France.

Theft
  In 1911, Peruggia perpetrated what has been described as the greatest art theft of the 20th century. It was a police theory that the former Louvre worker hid inside the museum on Sunday, August 20, knowing the museum would be closed the following day. But, according to Peruggia's interrogation in Florence after his arrest, he entered the museum on Monday, August 21 around 7 am, through the door where the other Louvre workers were entering. He said he wore one of the white smocks that museum employees customarily wore and was indistinguishable from the other workers. When the Salon Carré, where the Mona Lisa hung, was empty, he lifted the painting off the four iron pegs that secured it to the wall and took it to a nearby service staircase. There, he removed the protective case and frame. Some people report that he concealed the painting (which Leonardo painted on wood) under his smock. But Peruggia was only 5'3", and the Mona Lisa measures approx. 21" x 30", so it would not fit under a smock worn by someone his size. Instead, he said he took off his smock and wrapped it around the painting, tucked it under his arm, and left the Louvre through the same door he had entered.
  Peruggia hid the painting in his apartment in Paris. Supposedly, when police arrived to search his apartment and question him, they accepted his alibi that he had been working at a different location on the day of the theft.
  After keeping the painting hidden in a trunk in his apartment for two years, Peruggia returned to Italy with it. He kept it in his apartment in Florence, Italy but grew impatient, and was finally caught when he contacted Alfredo Geri, the owner of an art gallery in Florence. Geri's story conflicts with Peruggia's, but it was clear that Peruggia expected a reward for returning the painting to what he regarded as its "homeland". Geri called in Giovanni Poggi, director of the Uffizi Gallery, who authenticated the painting. Poggi and Geri, after taking the painting for "safekeeping", informed the police, who arrested Peruggia at his hotel. After its recovery, the painting was exhibited all over Italy with banner headlines rejoicing its return and then returned to the Louvre in 1913.
  Later life and personal life
Peruggia was released from jail after a short time and served in the Italian army during World War I. He later married, had one daughter, Celestina, returned to France, and continued to work as a painter decorator using his birth name Pietro Peruggia.
Death
 He died on October 8, 1925 (his 44th birthday) in the town of Saint-Maur-des-Fossés, France. His death was not widely reported on by the media; obituaries appeared mistakenly only when another Vincenzo Peruggia died in Haute-Savoie in 1947.

Motivations
  There are currently two predominant theories regarding the theft of the Mona Lisa.
Patriotism Peruggia said he did it for a patriotic reason: he wanted to bring the painting back for display in Italy "after it was stolen by Napoleon". Although perhaps sincere in his motive, Vincenzo may not have known that Leonardo da Vinci took this painting as a gift for Francis I when he moved to France to become a painter in his court during the 16th century, 250 years before Napoleon's birth.
Experts have questioned the "patriotism" motive on the grounds that—were patriotism the true motive—Peruggia would have donated the painting to an Italian museum, rather than attempted to profit from its sale. The question of money is also confirmed by letters that Peruggia sent to his father after the theft. On December 22, 1911, four months after the theft, he wrote that Paris was where "I will make my fortune and that his (fortune) will arrive in one shot." The following year (1912), he wrote: "I am making a vow for you to live long and enjoy the prize that your son is about to realize for you and for all our family."
Put on trial, the court agreed to some extent that Peruggia committed his crime for patriotic reasons and gave him a lenient sentence. He was sent to jail for one year and 15 days, but was hailed as a great patriot in Italy and served only seven months in jail.

Criminal conspiracy
Another theory emerged later. The theft may have been encouraged or masterminded by Eduardo de Valfierno, a con-man who had commissioned the French art forger Yves Chaudron to make copies of the painting so he could sell them as the missing original. The copies would have gone up in value if the original were stolen. This theory is based entirely on a 1932 article by former Hearst journalist Karl Decker in The Saturday Evening Post. Decker claimed to have known "Valfierno" and heard the story from him in 1913, promising not to print it until he learned of Valfierno's death. There is no external confirmation for this tale.

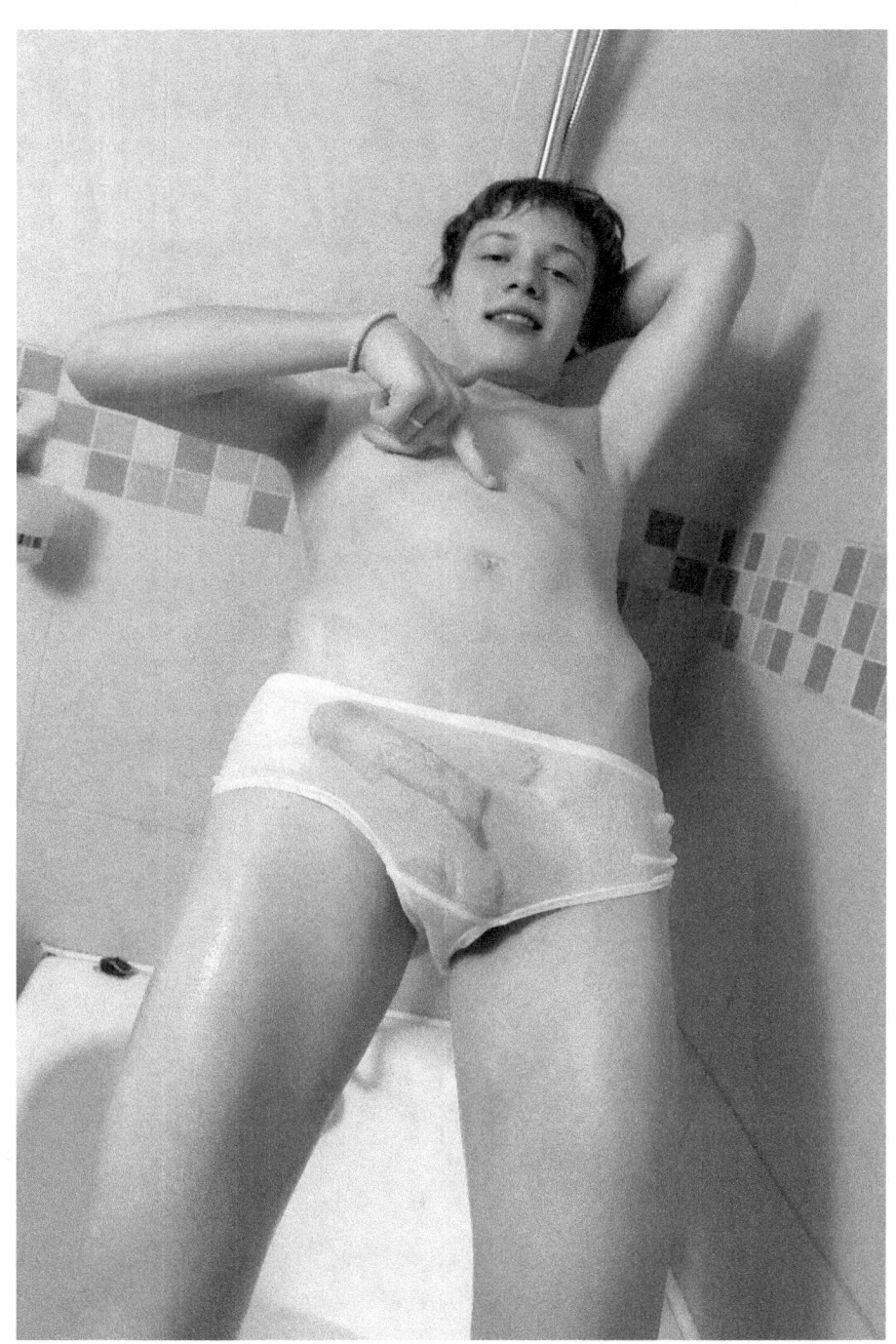

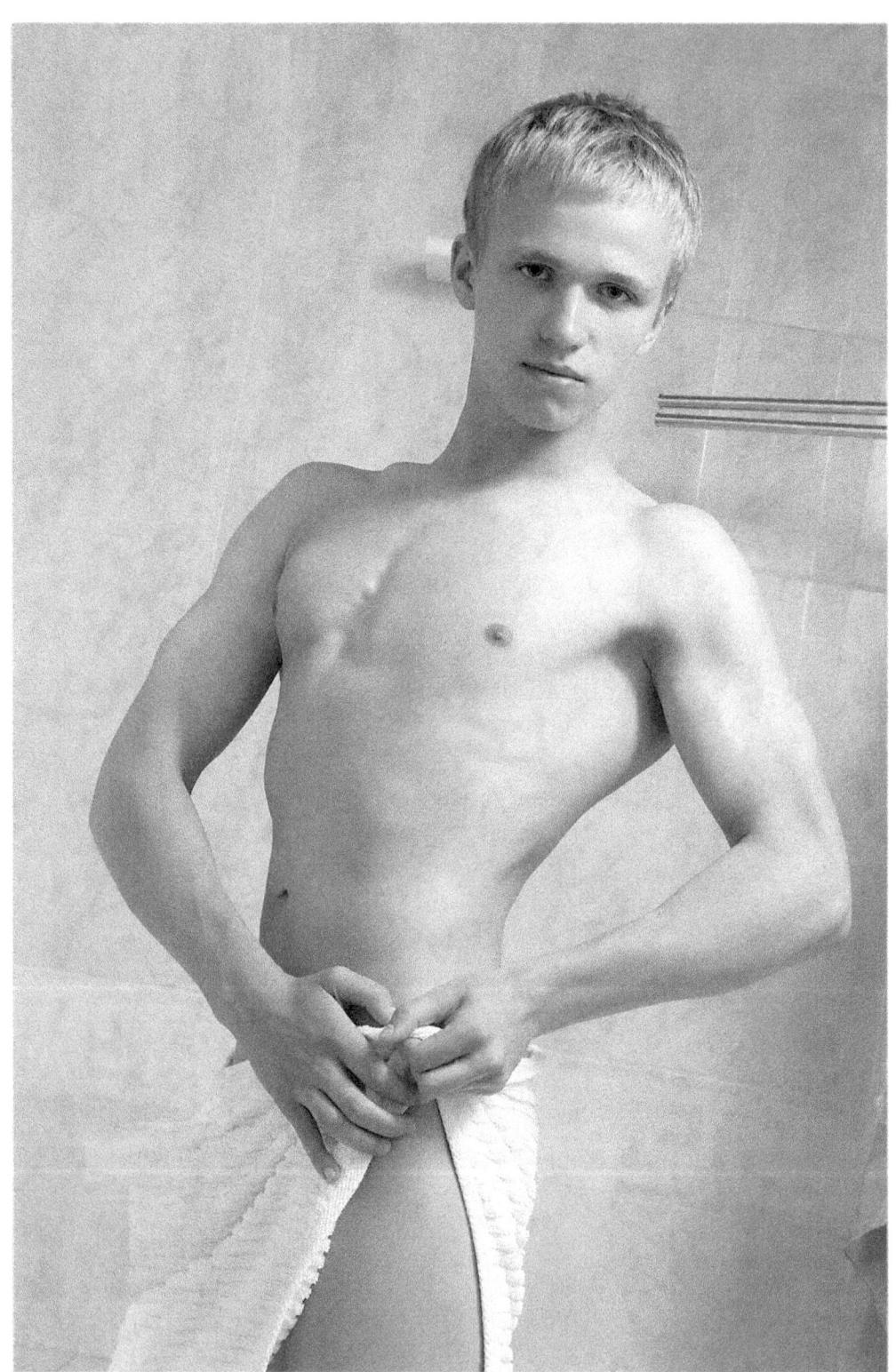

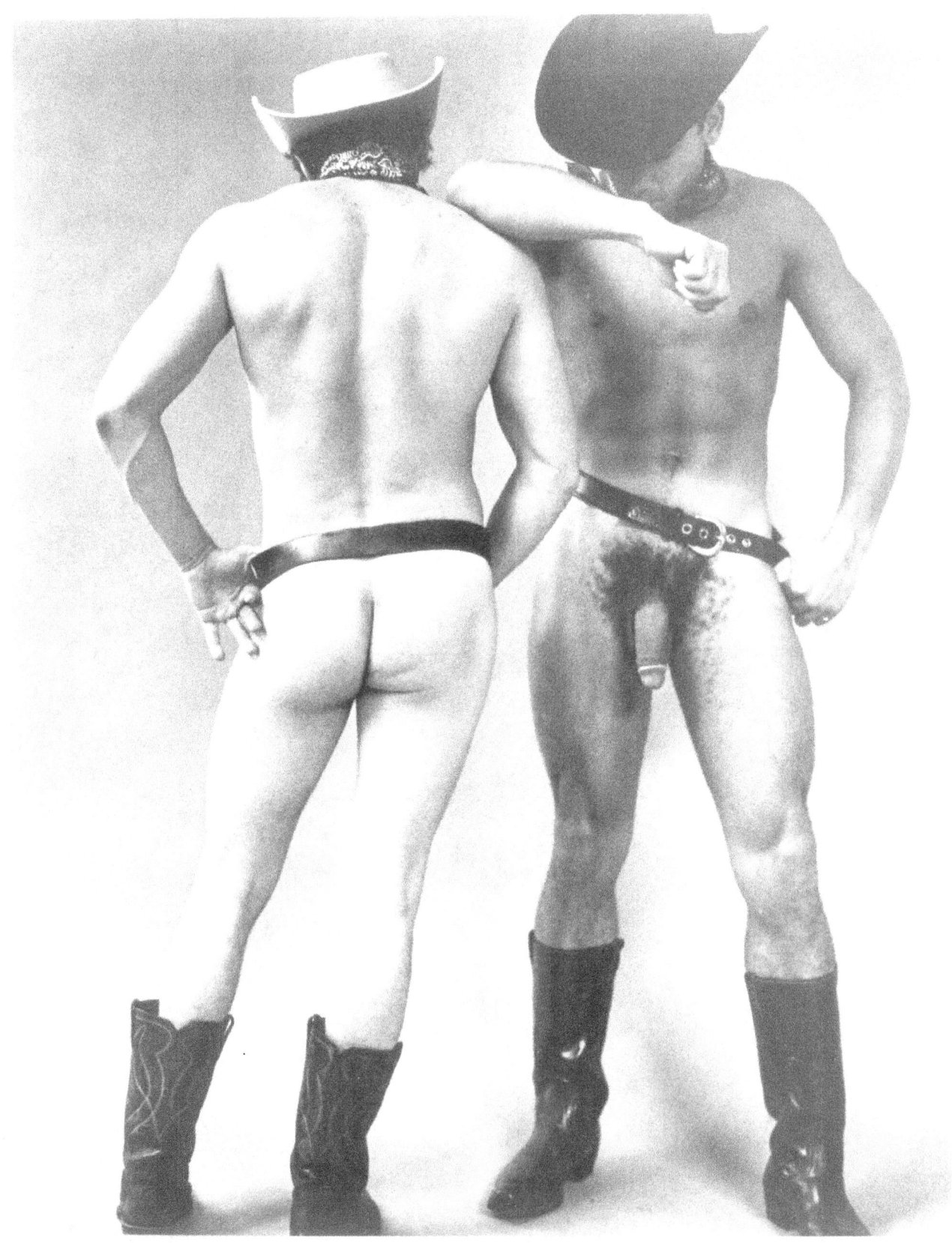

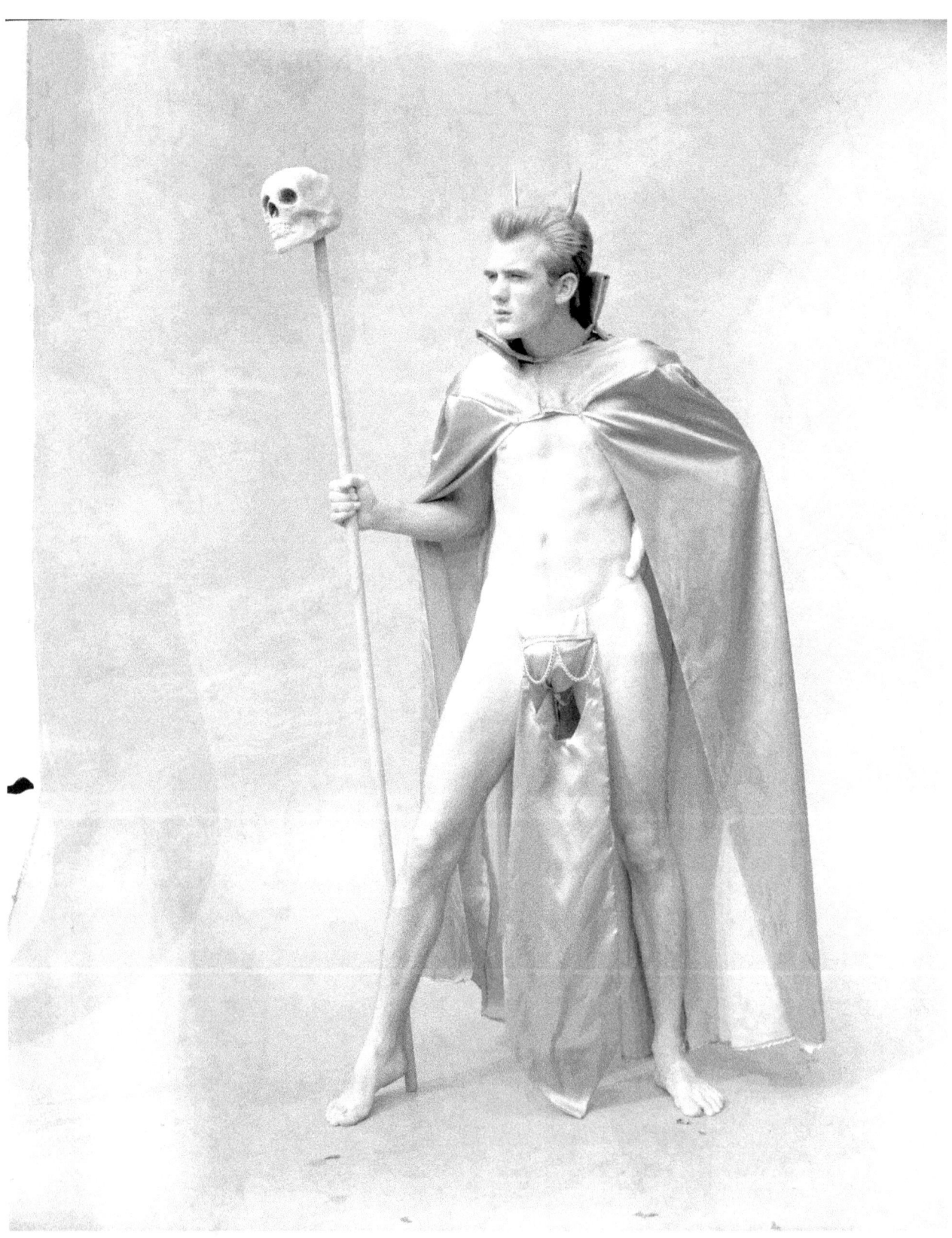

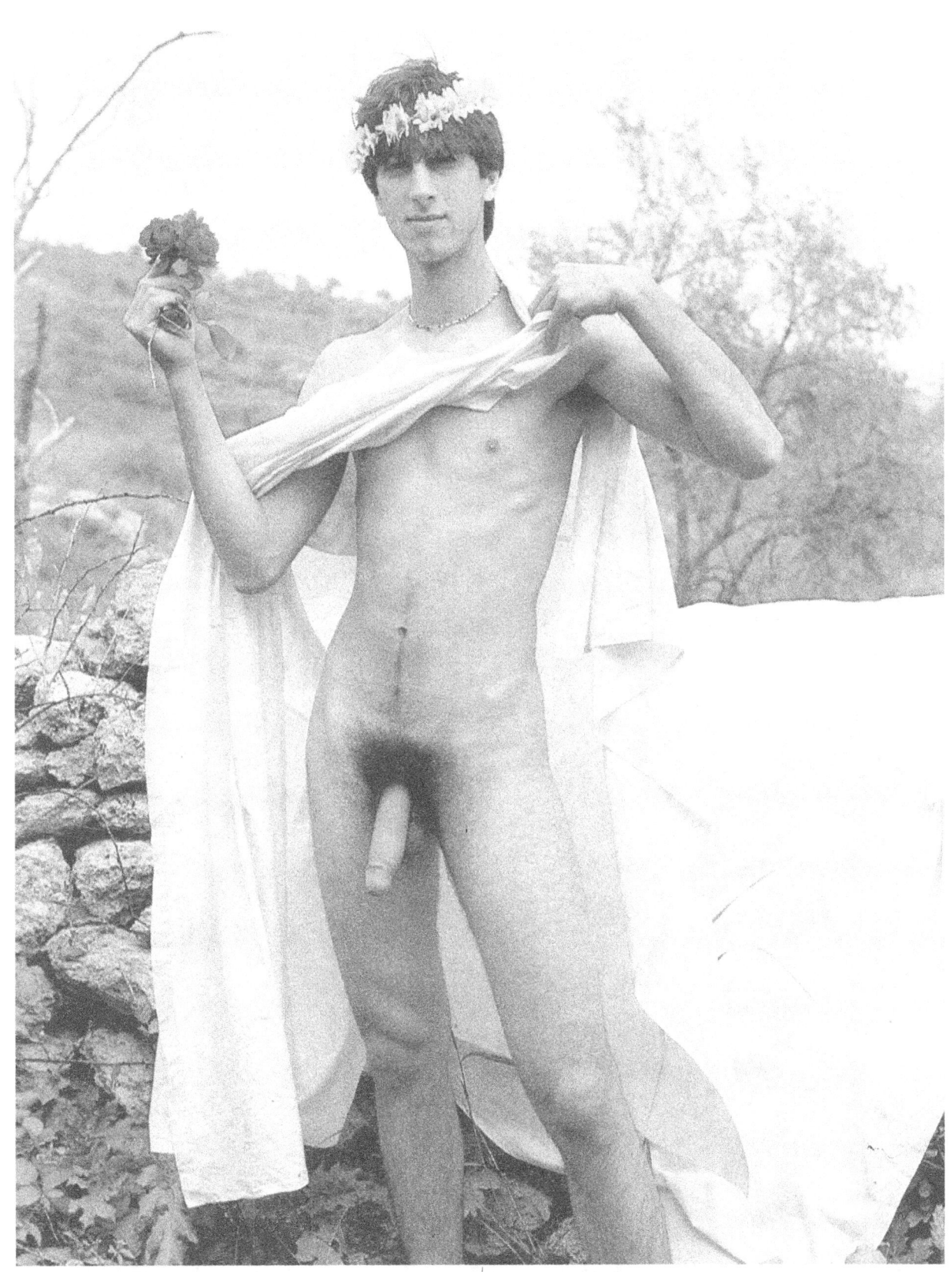

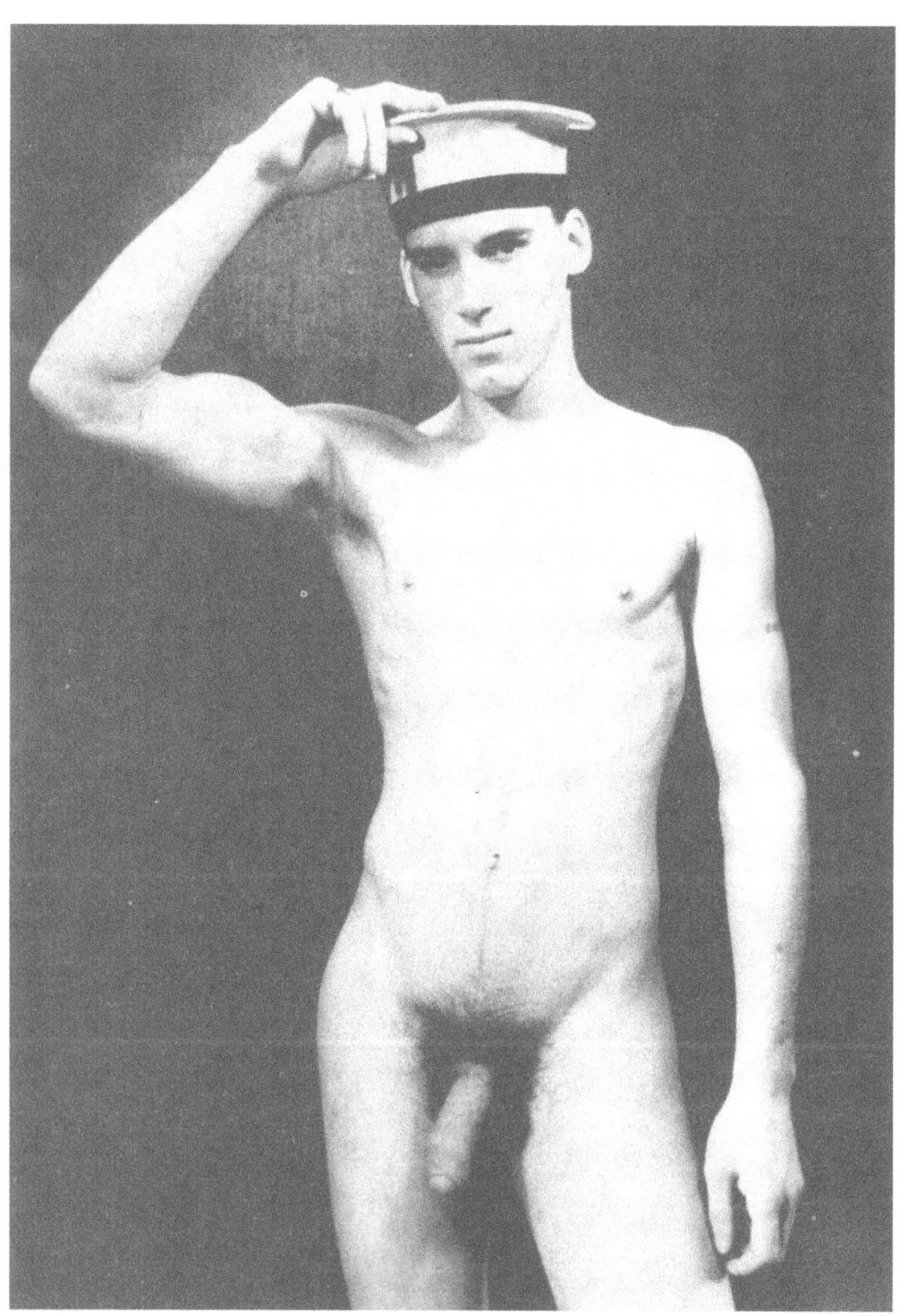

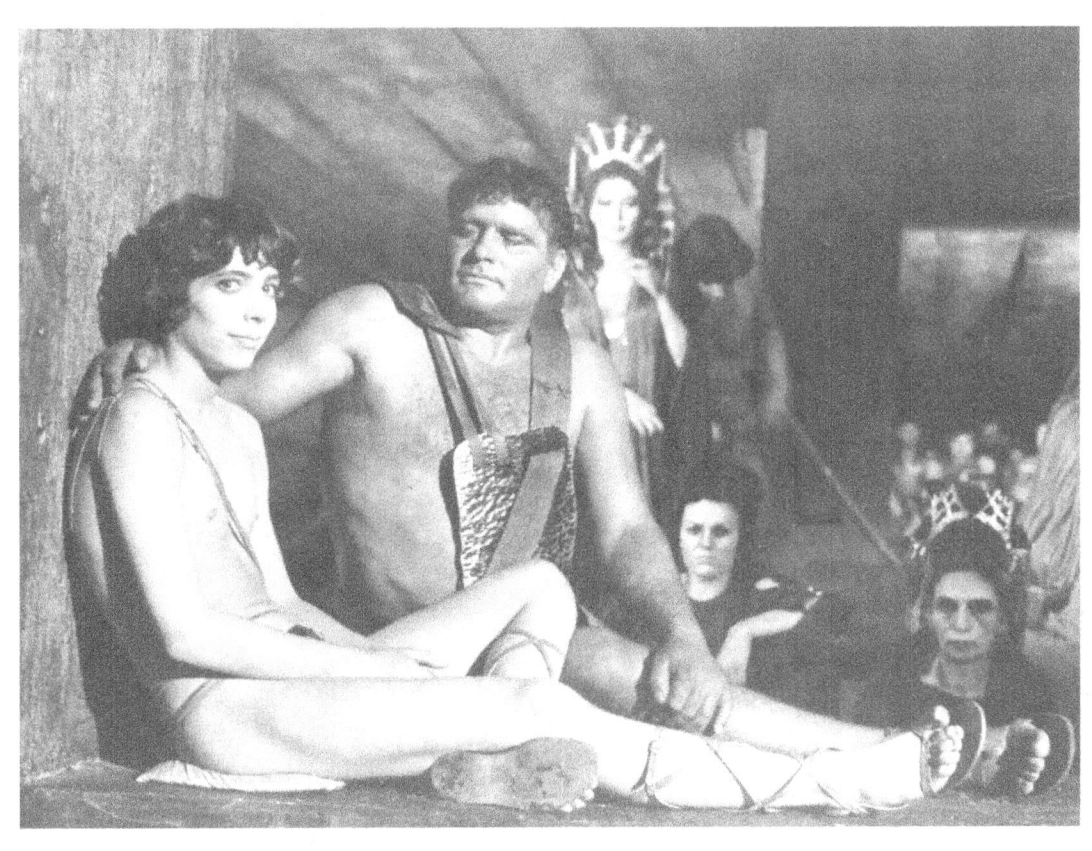
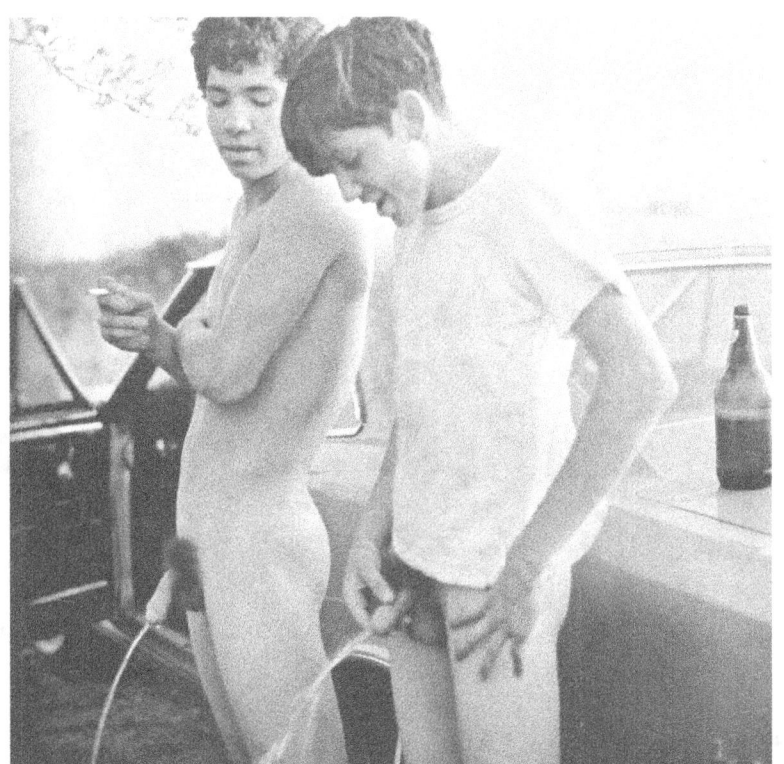

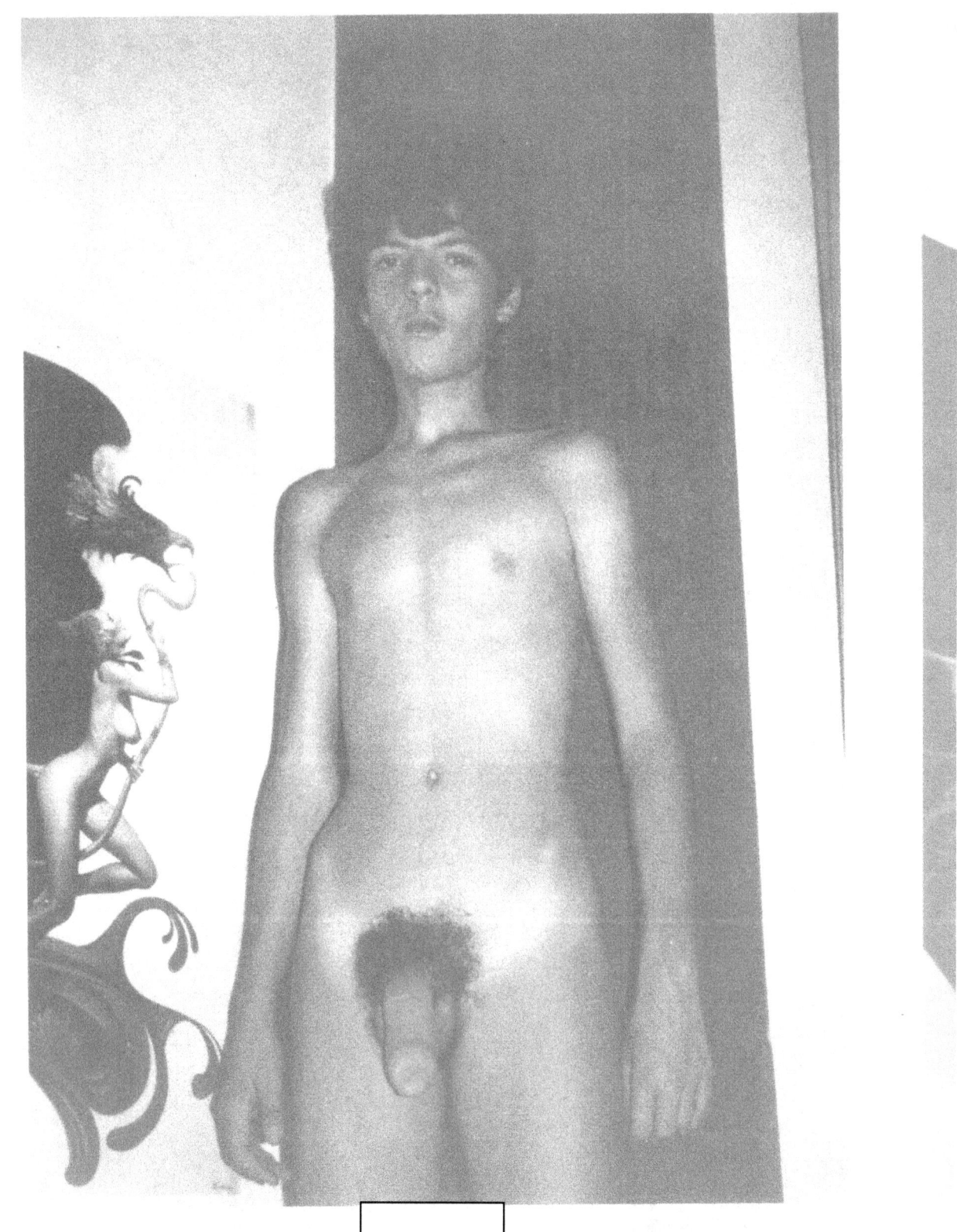

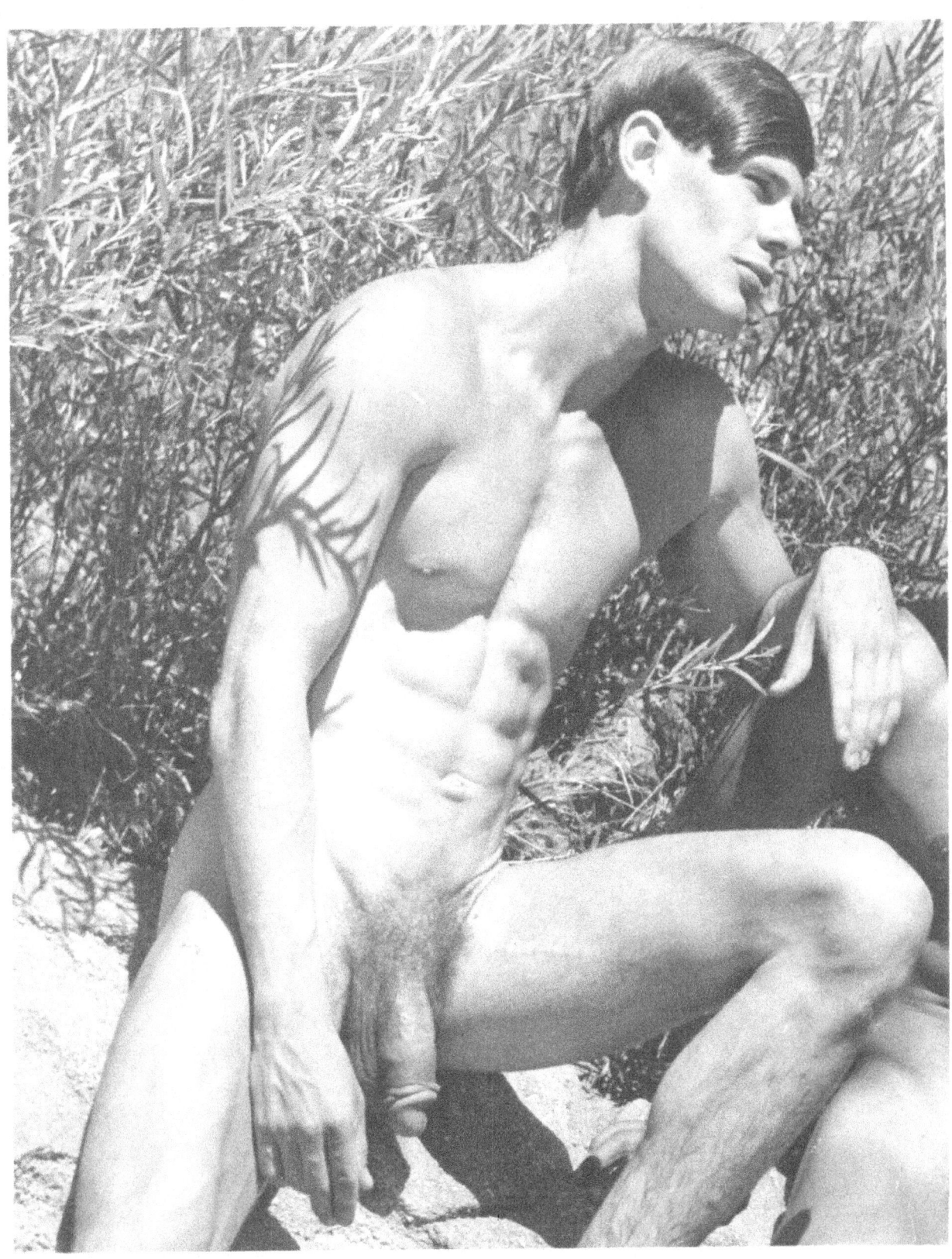

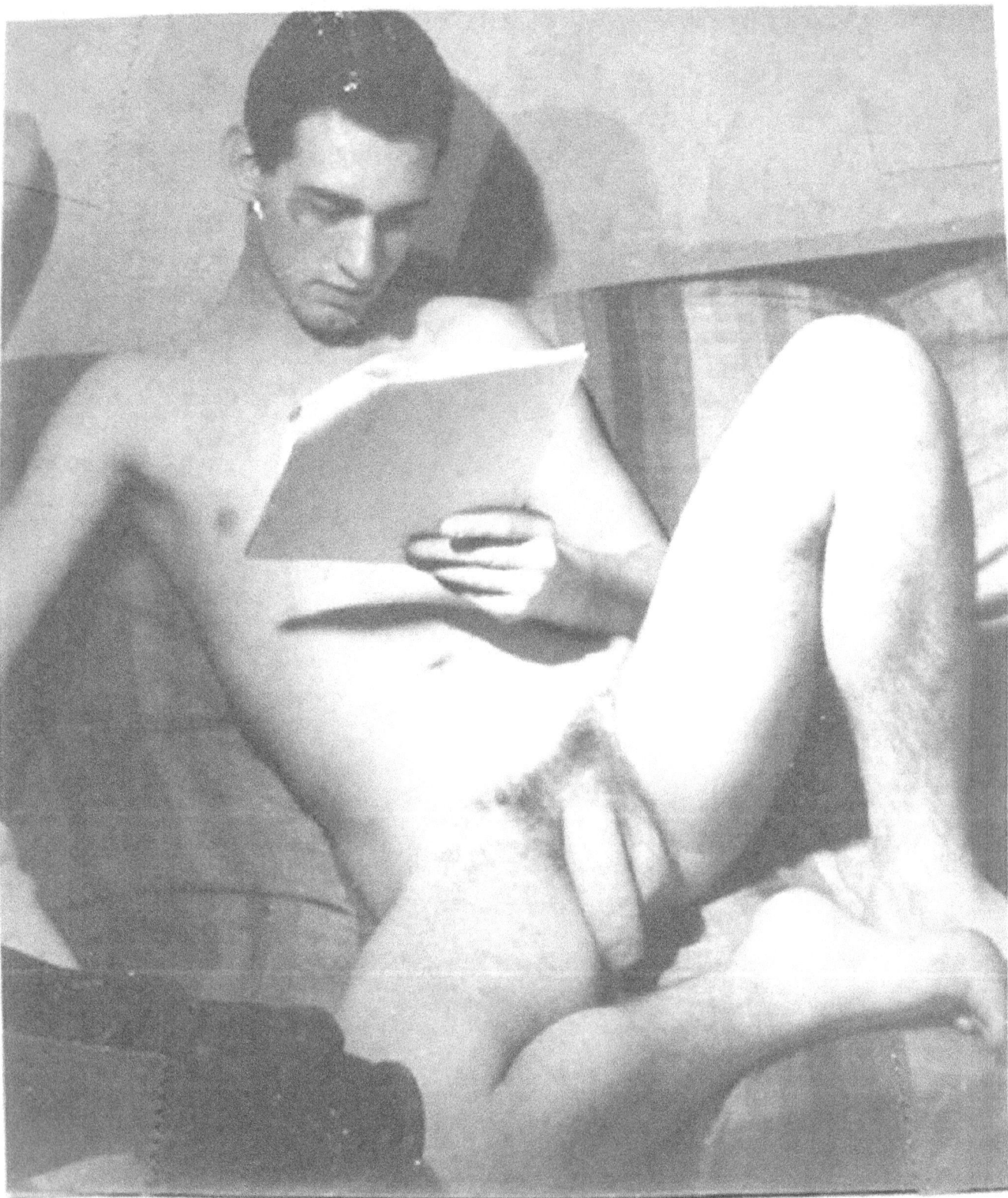

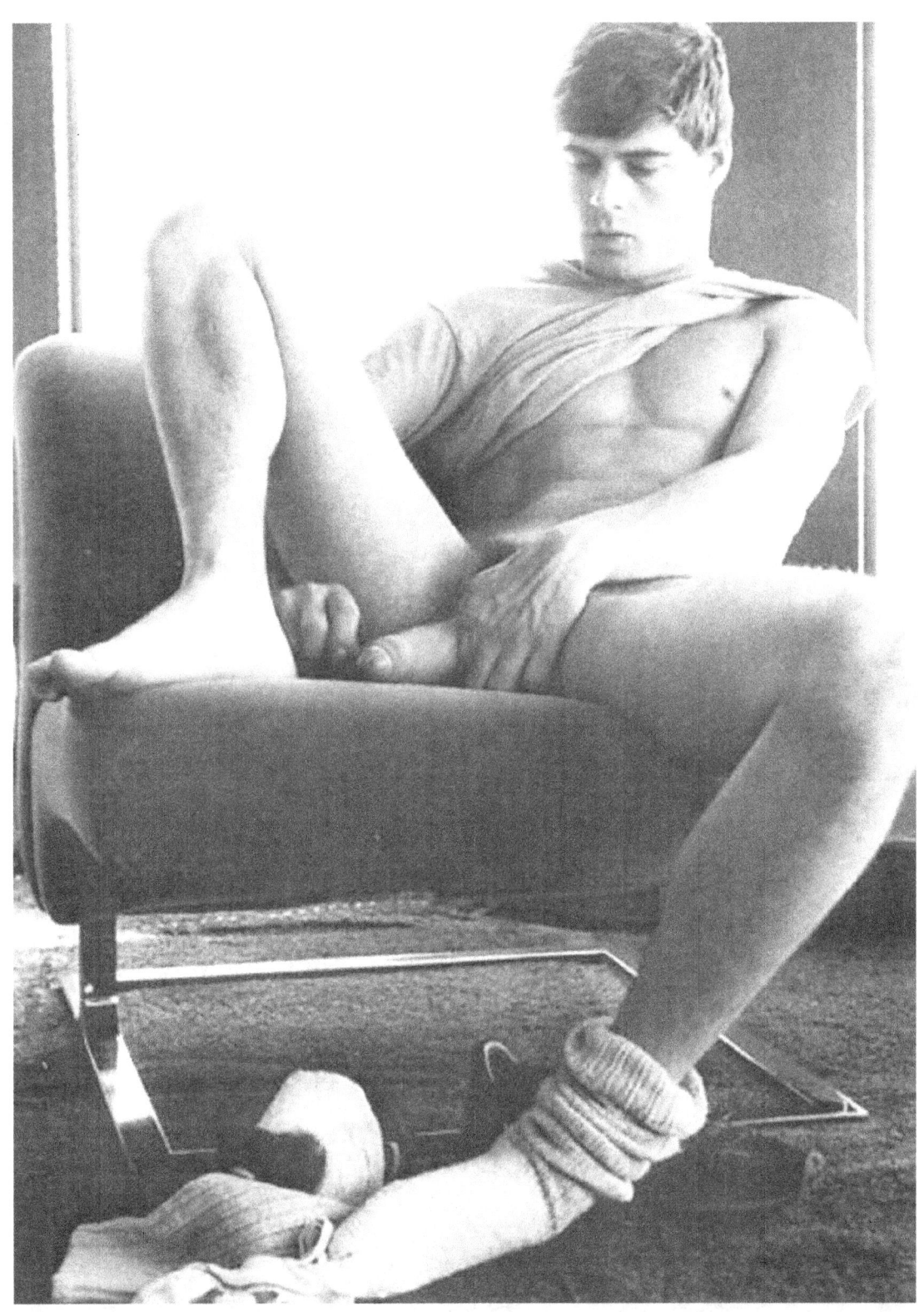

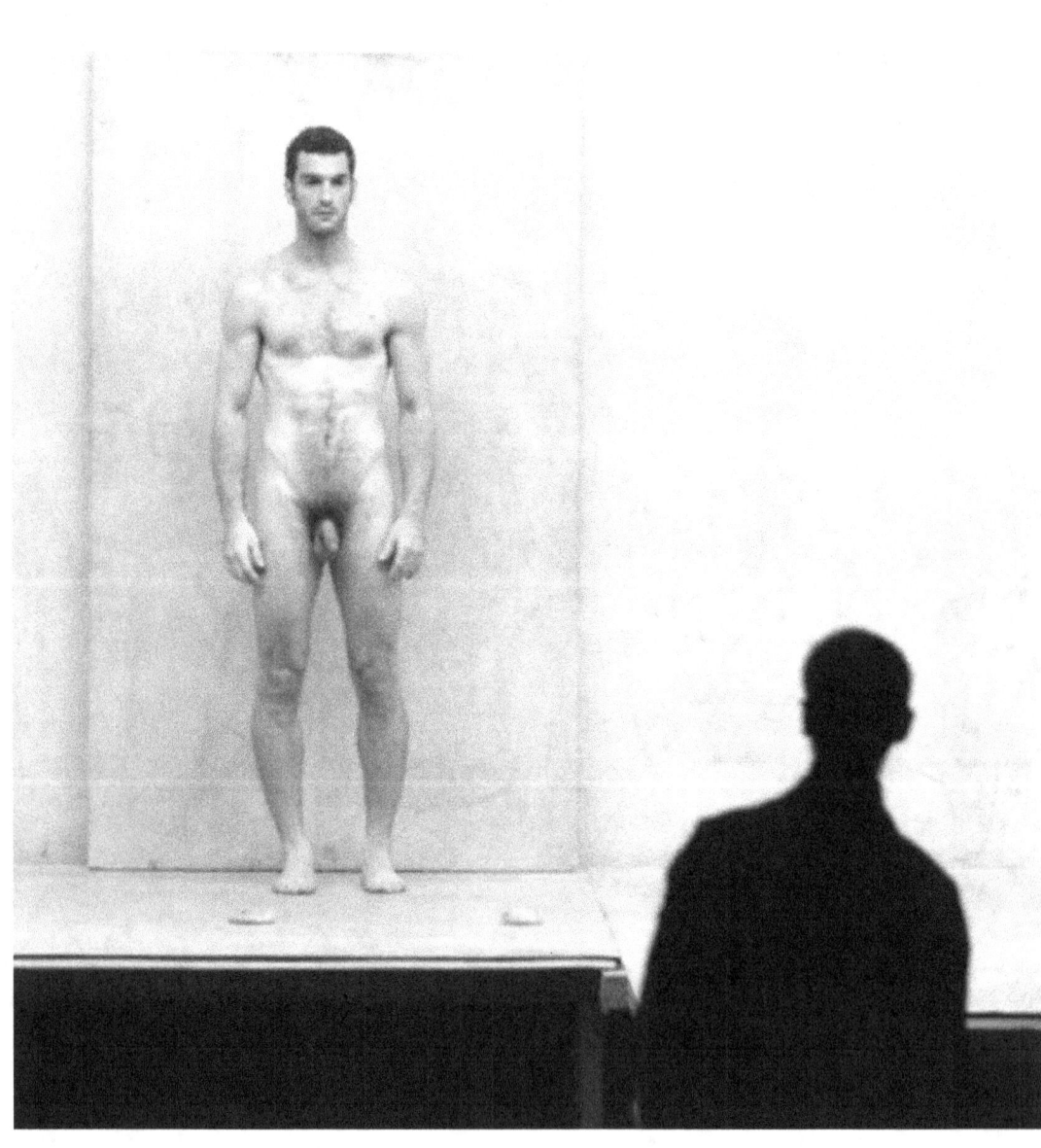

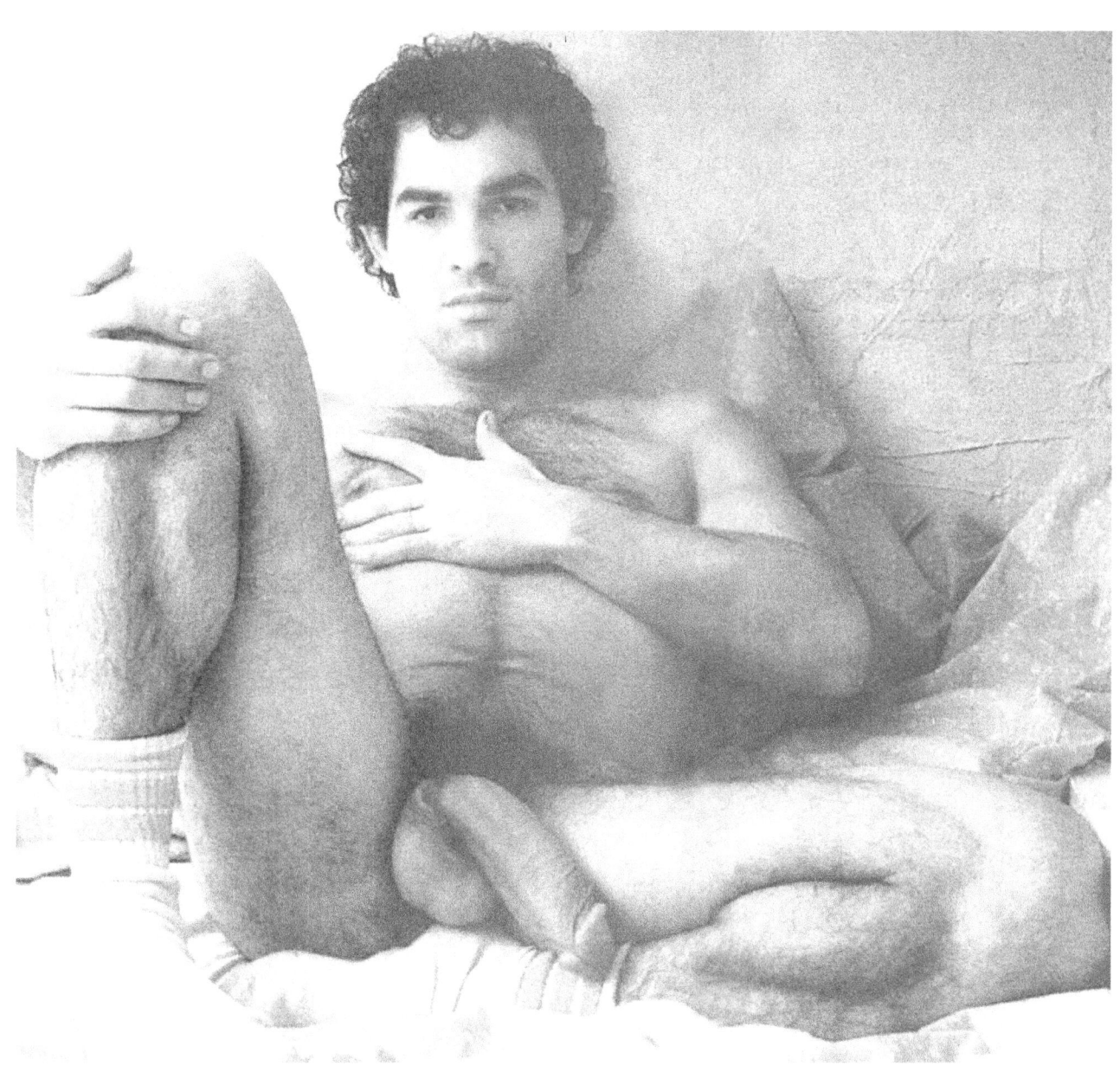

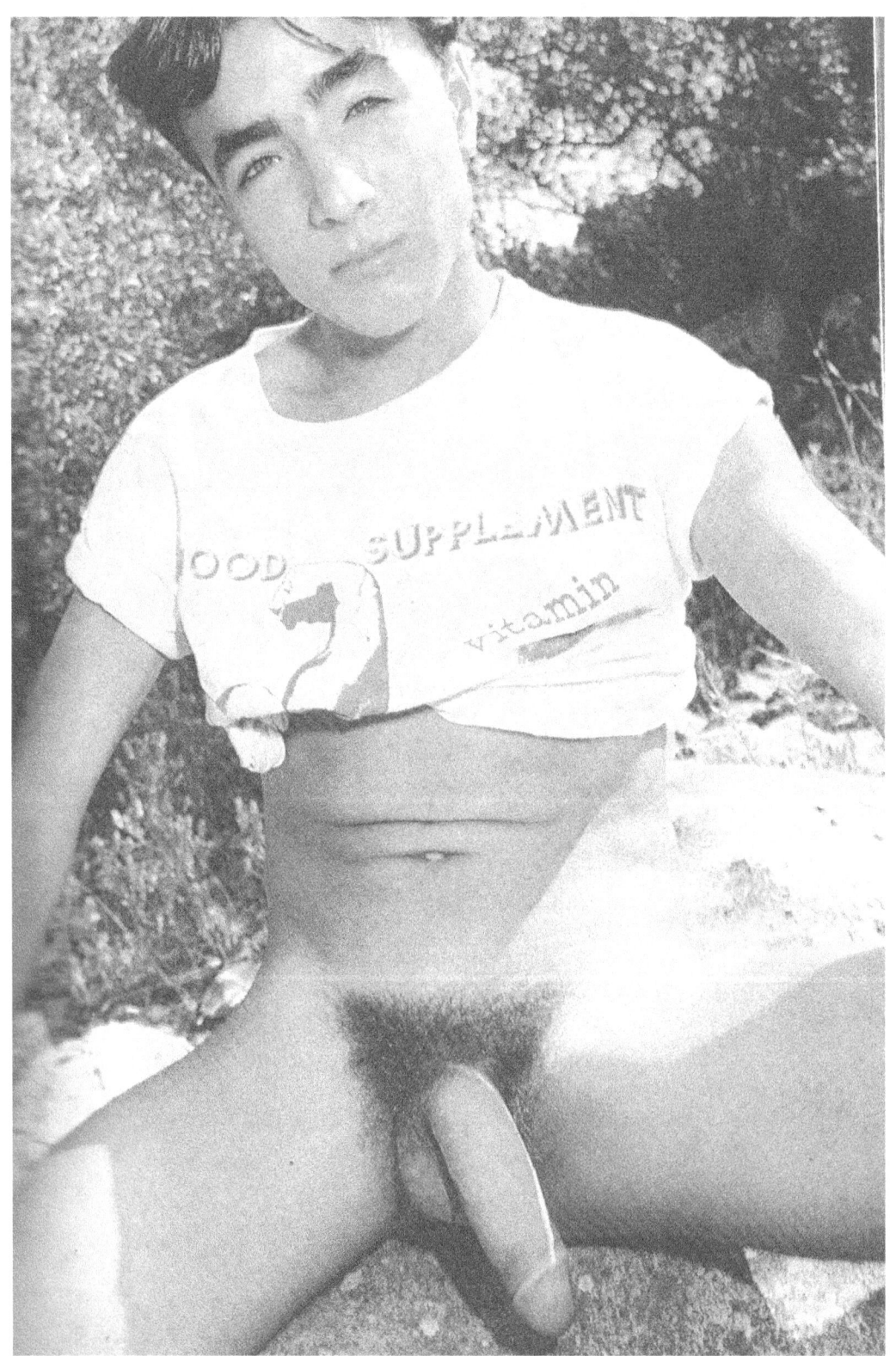

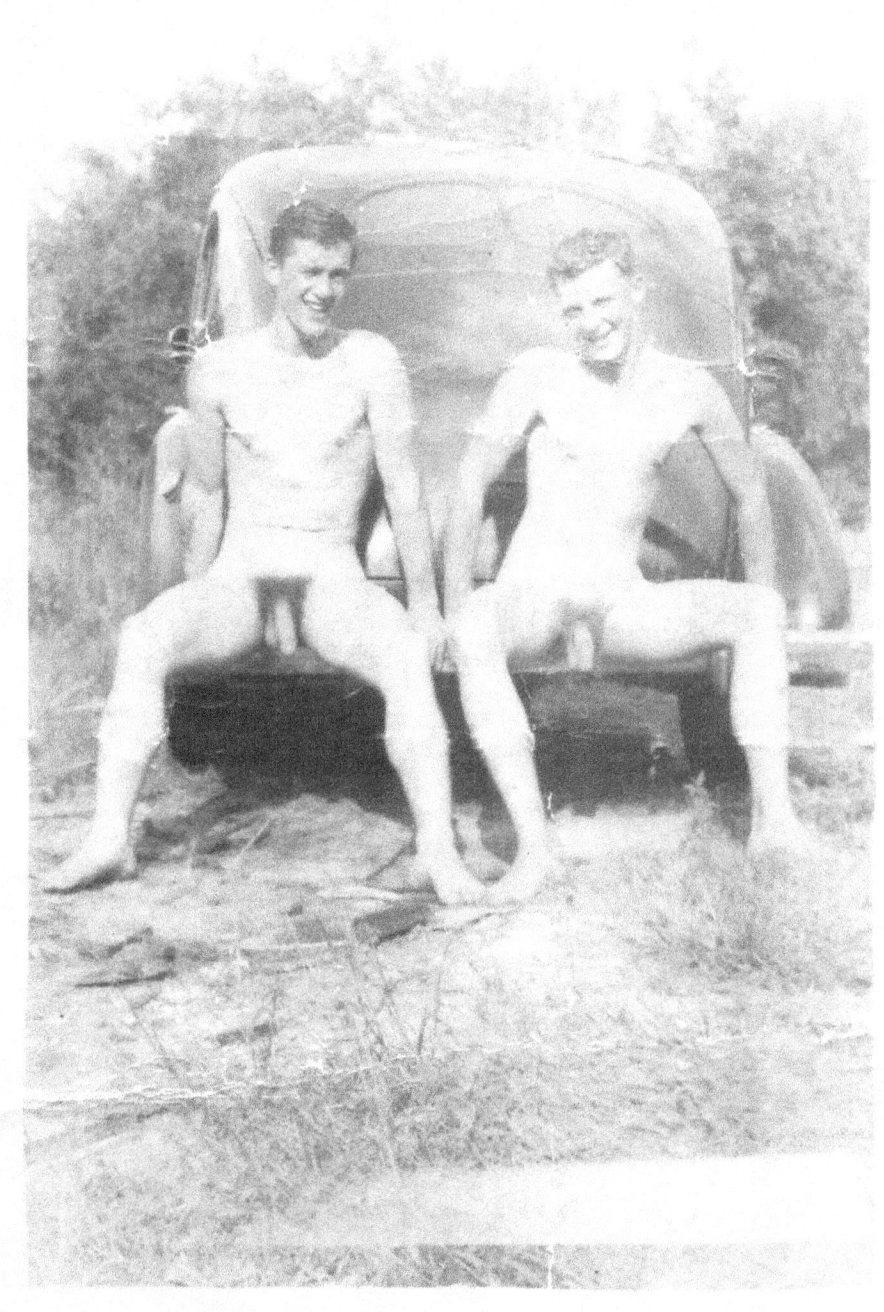

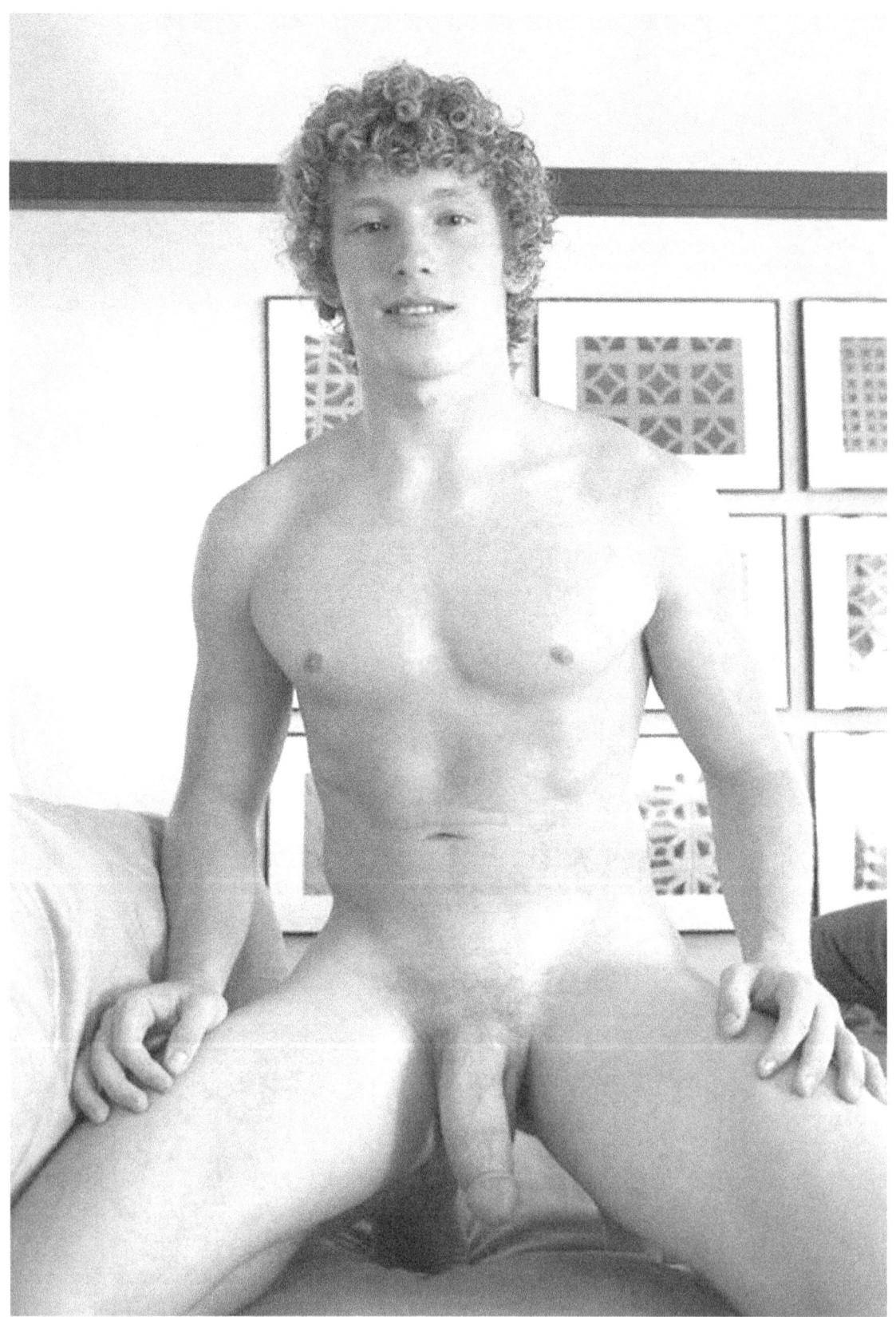

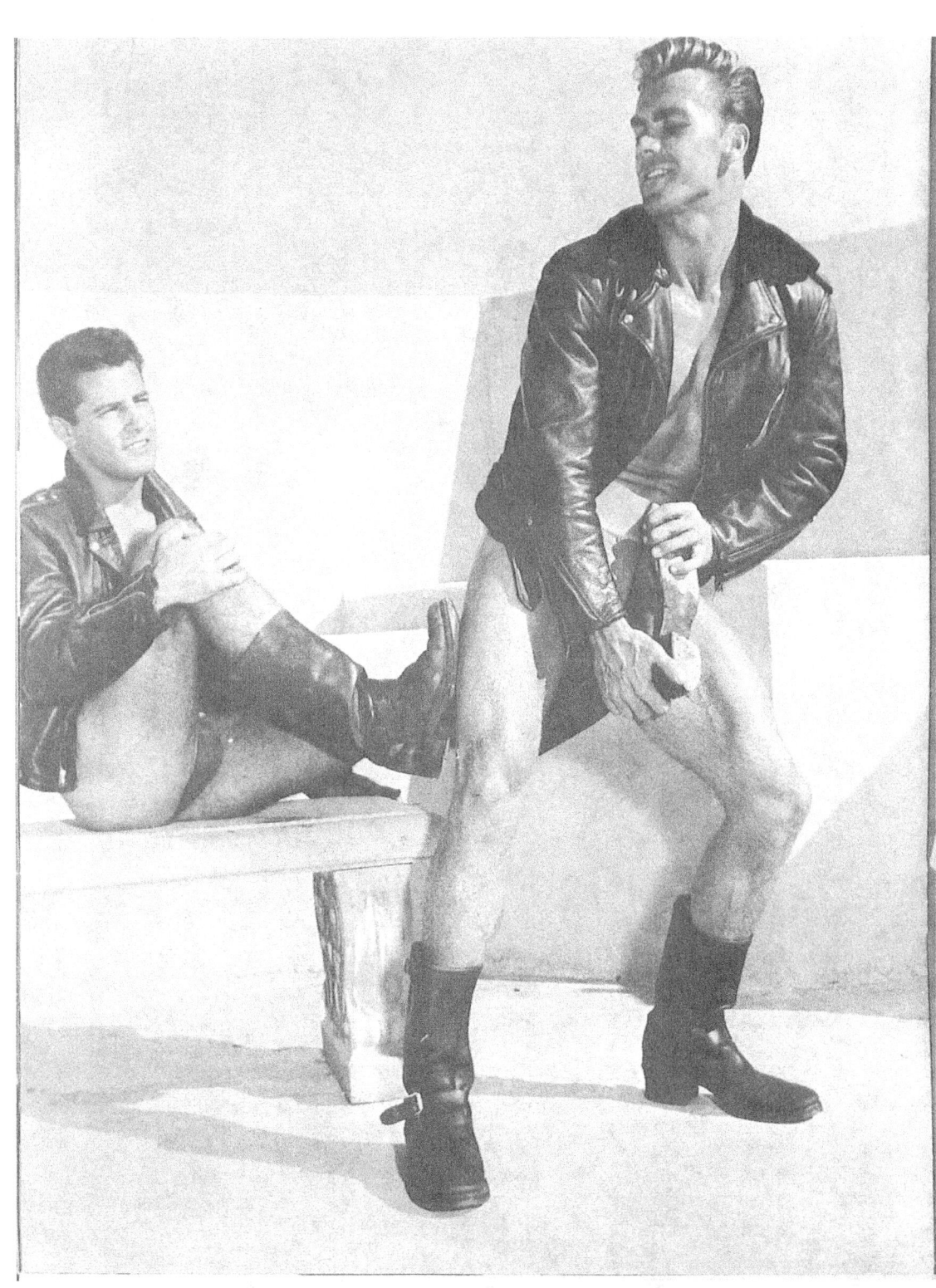

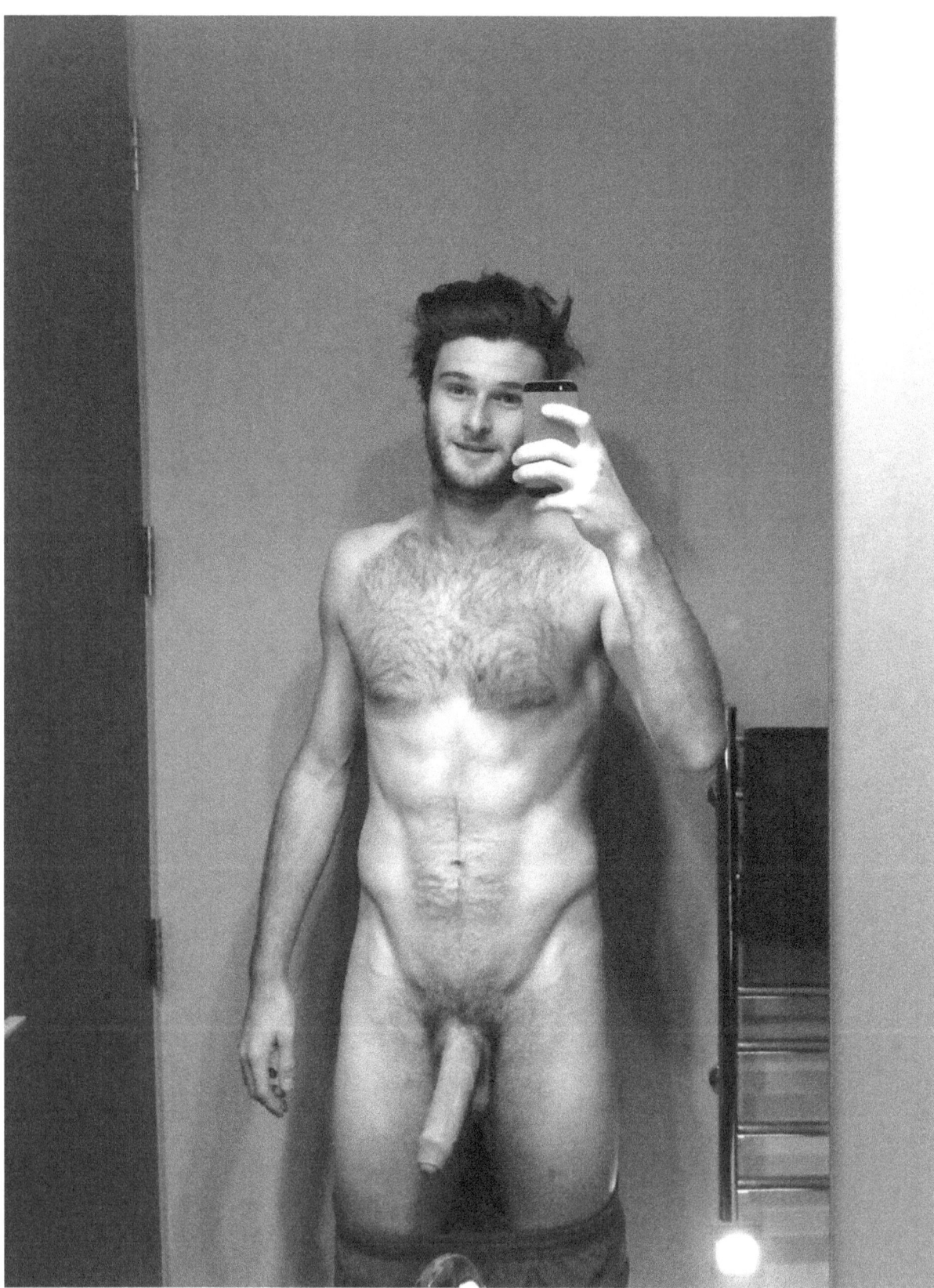

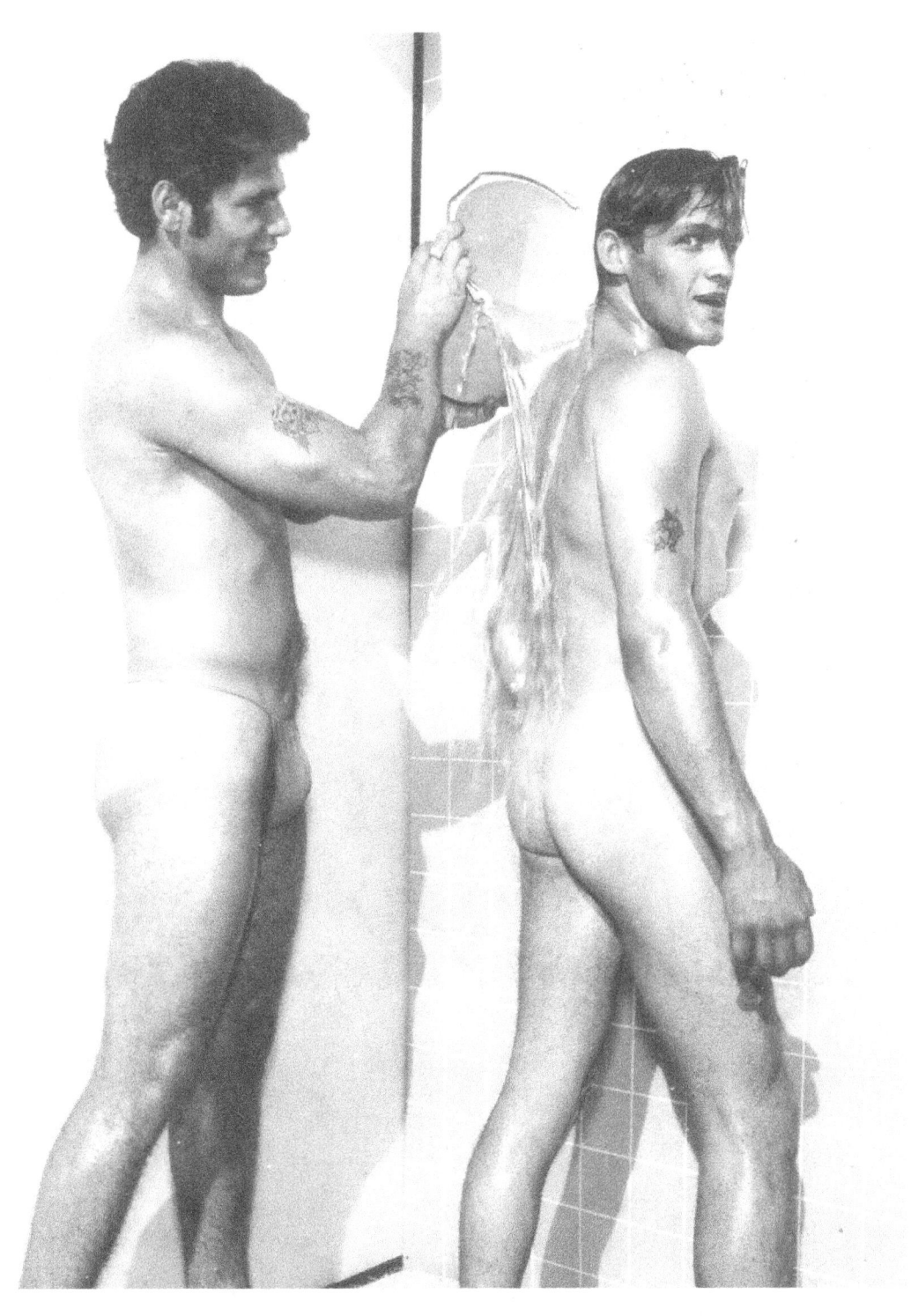

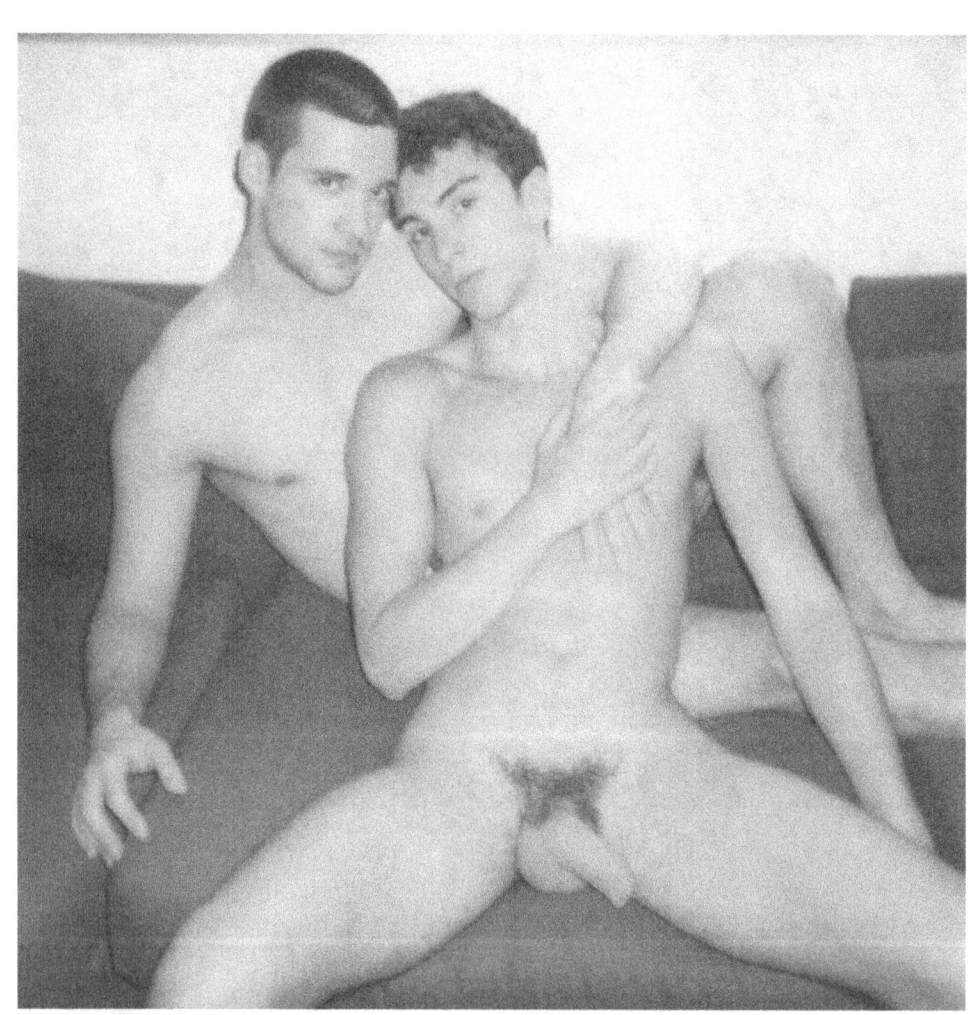

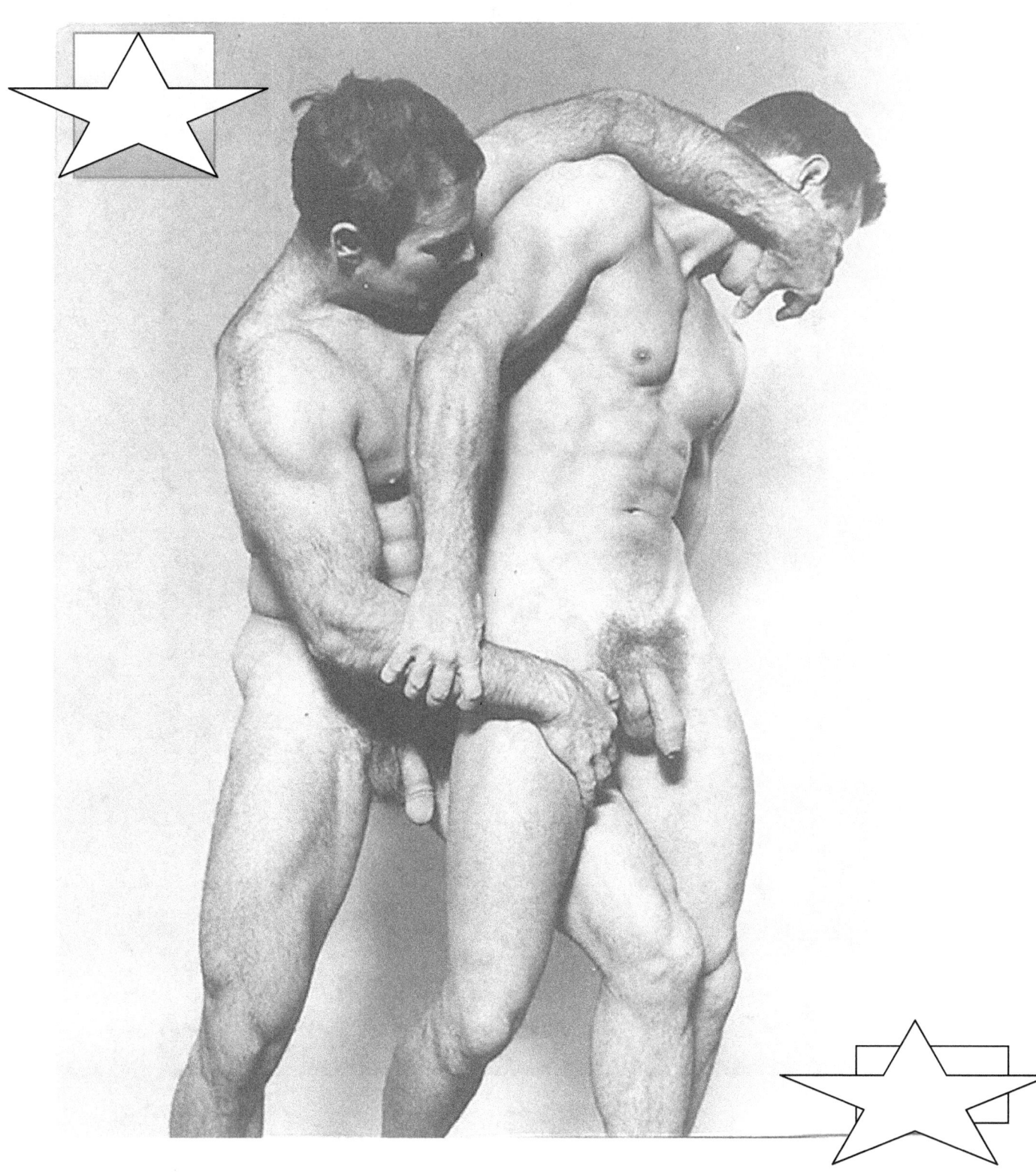

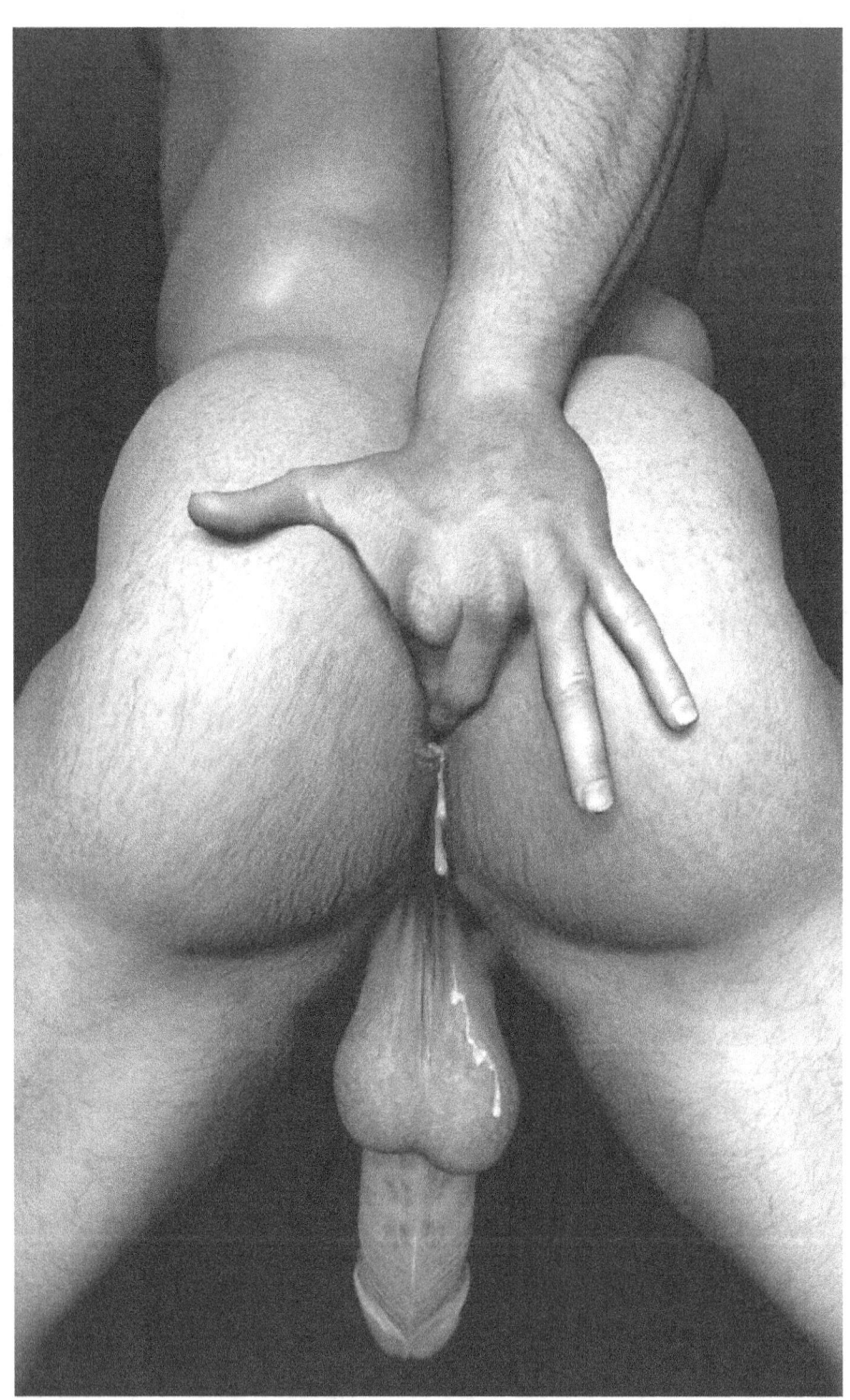

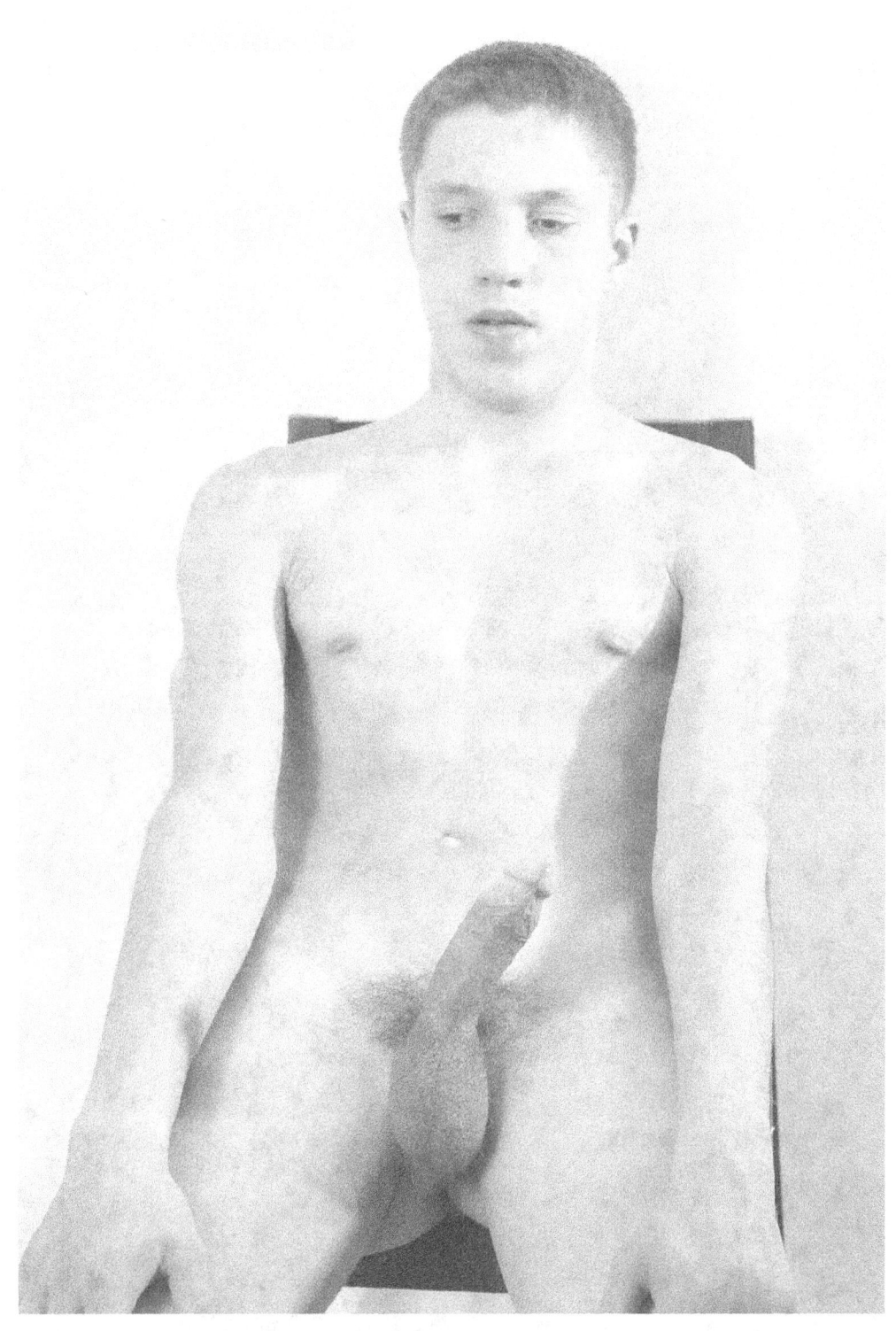

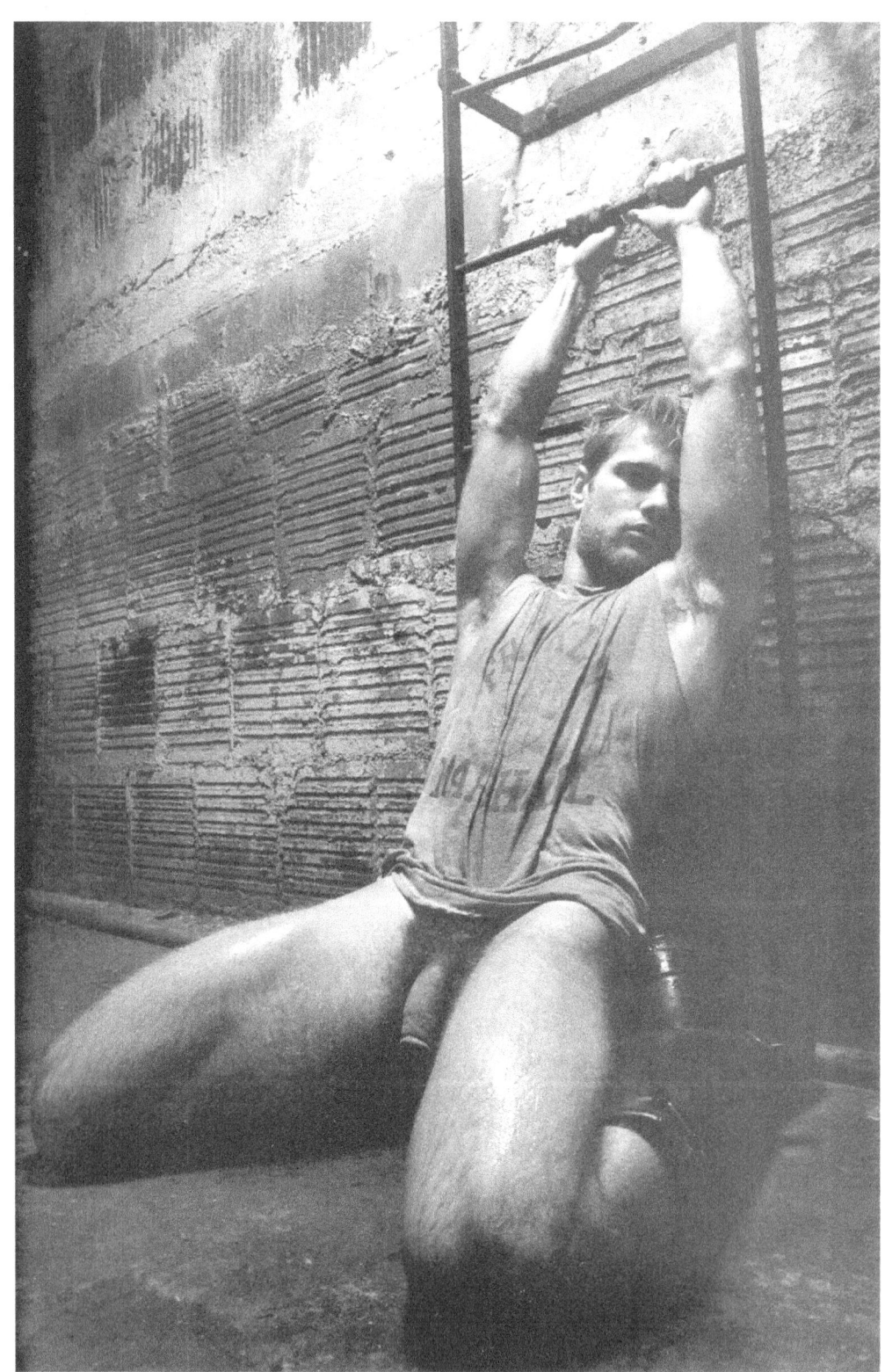

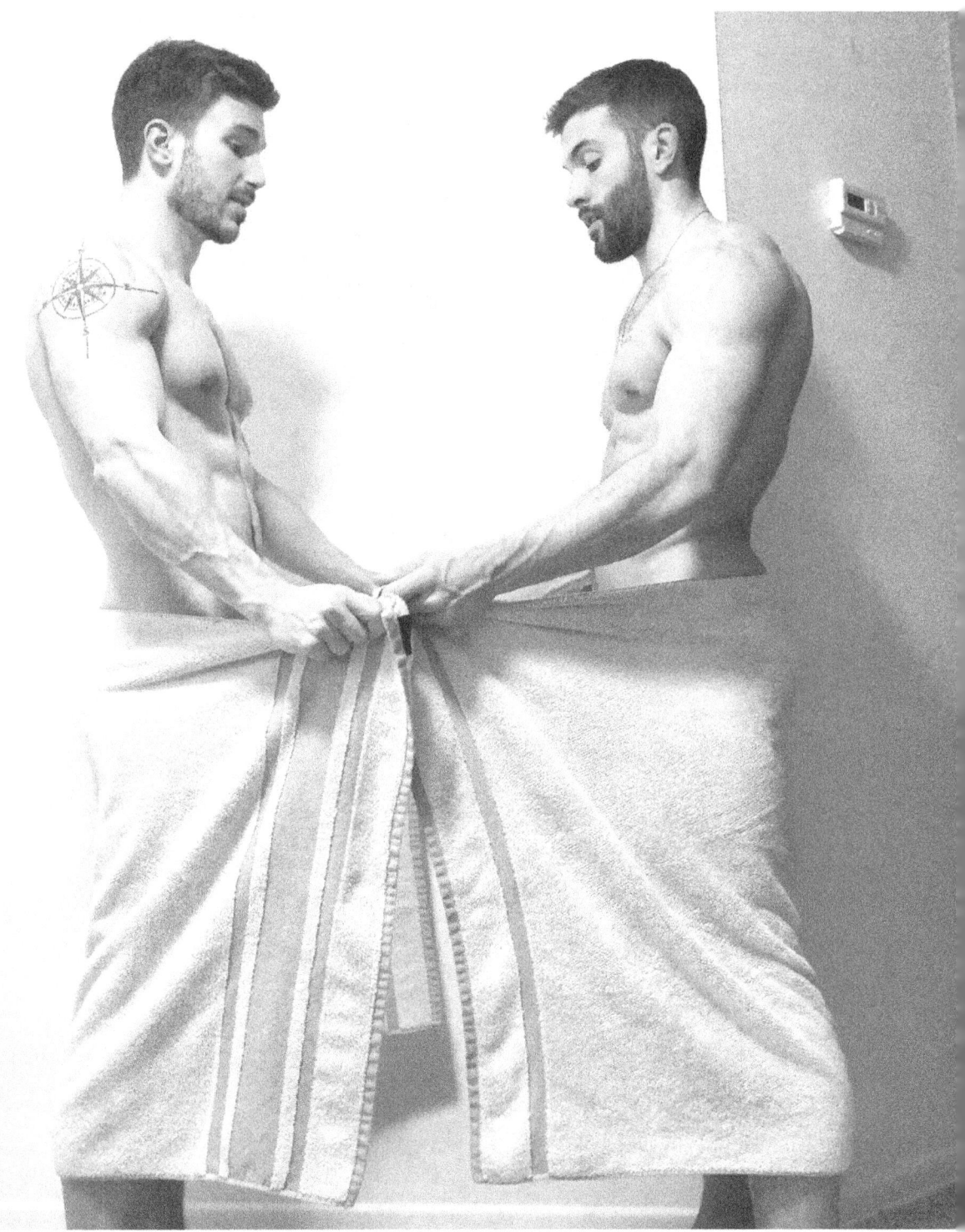

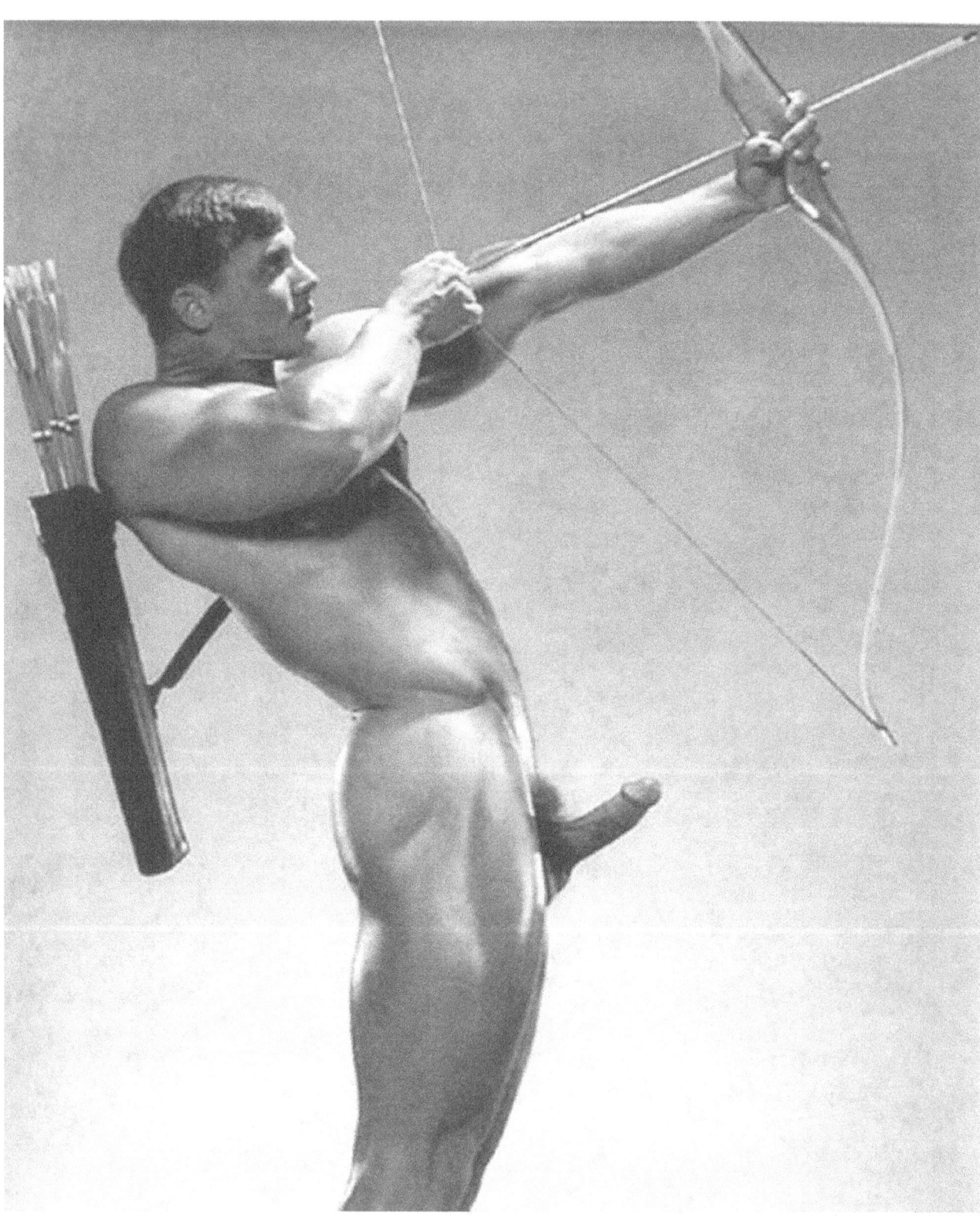

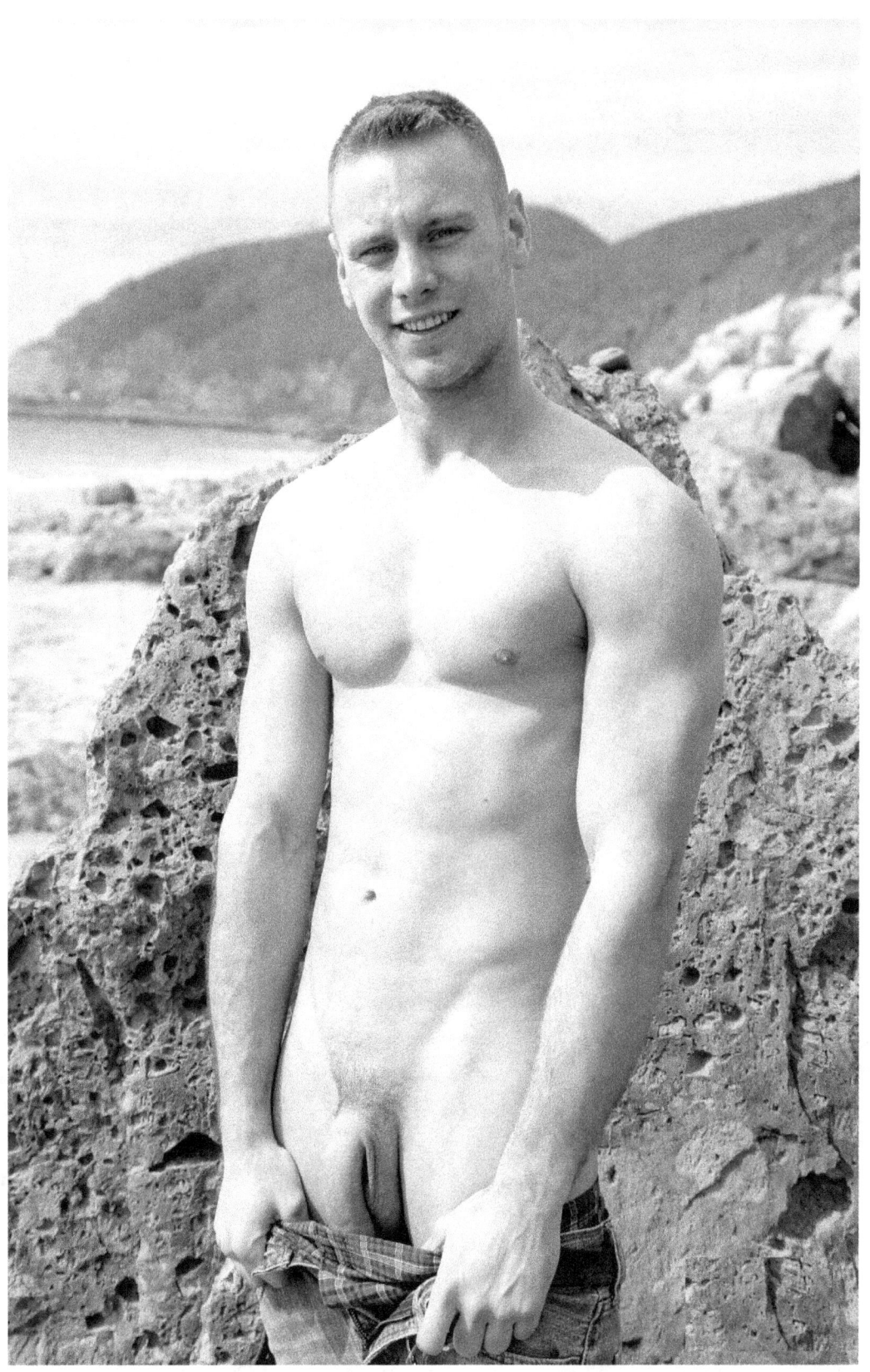

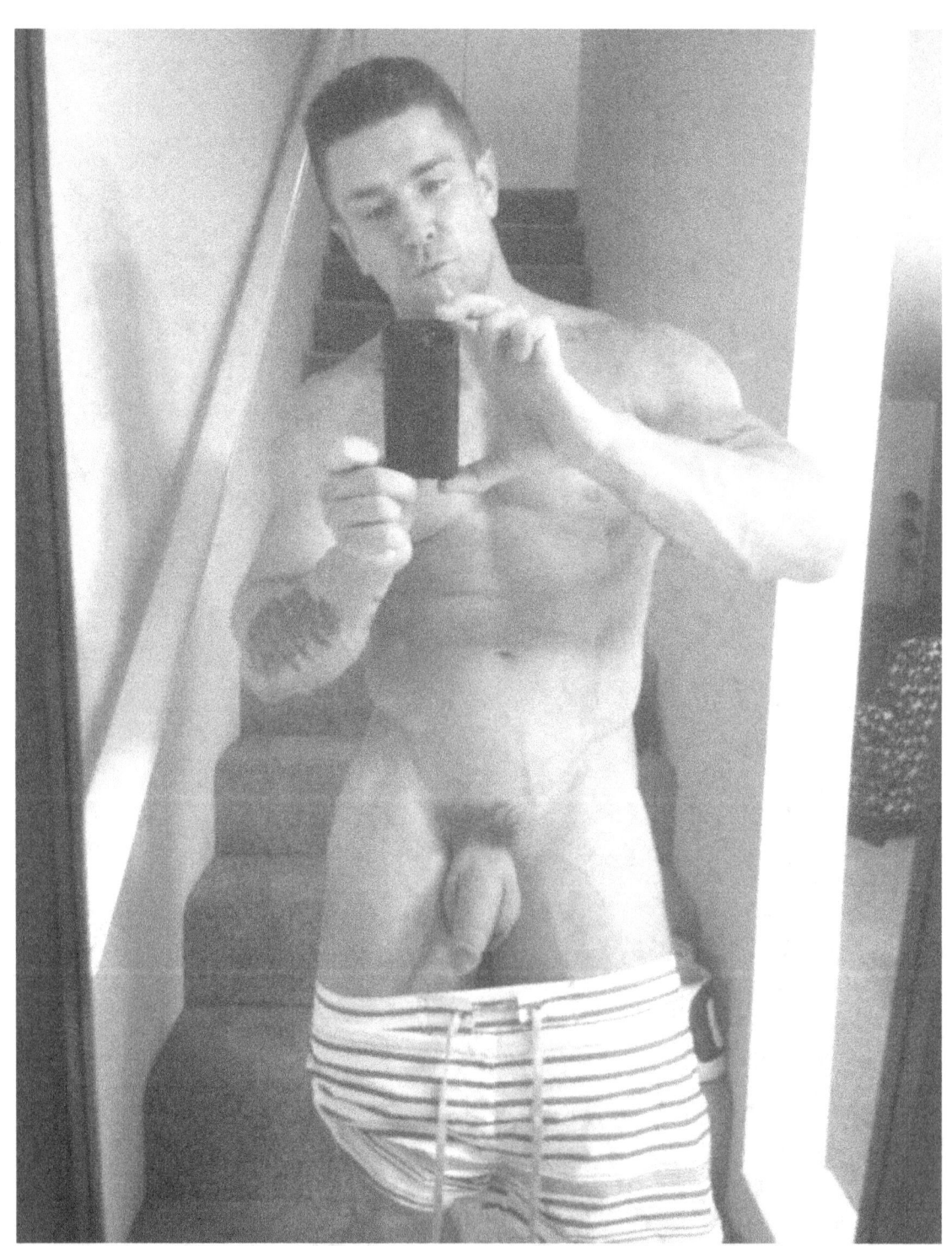

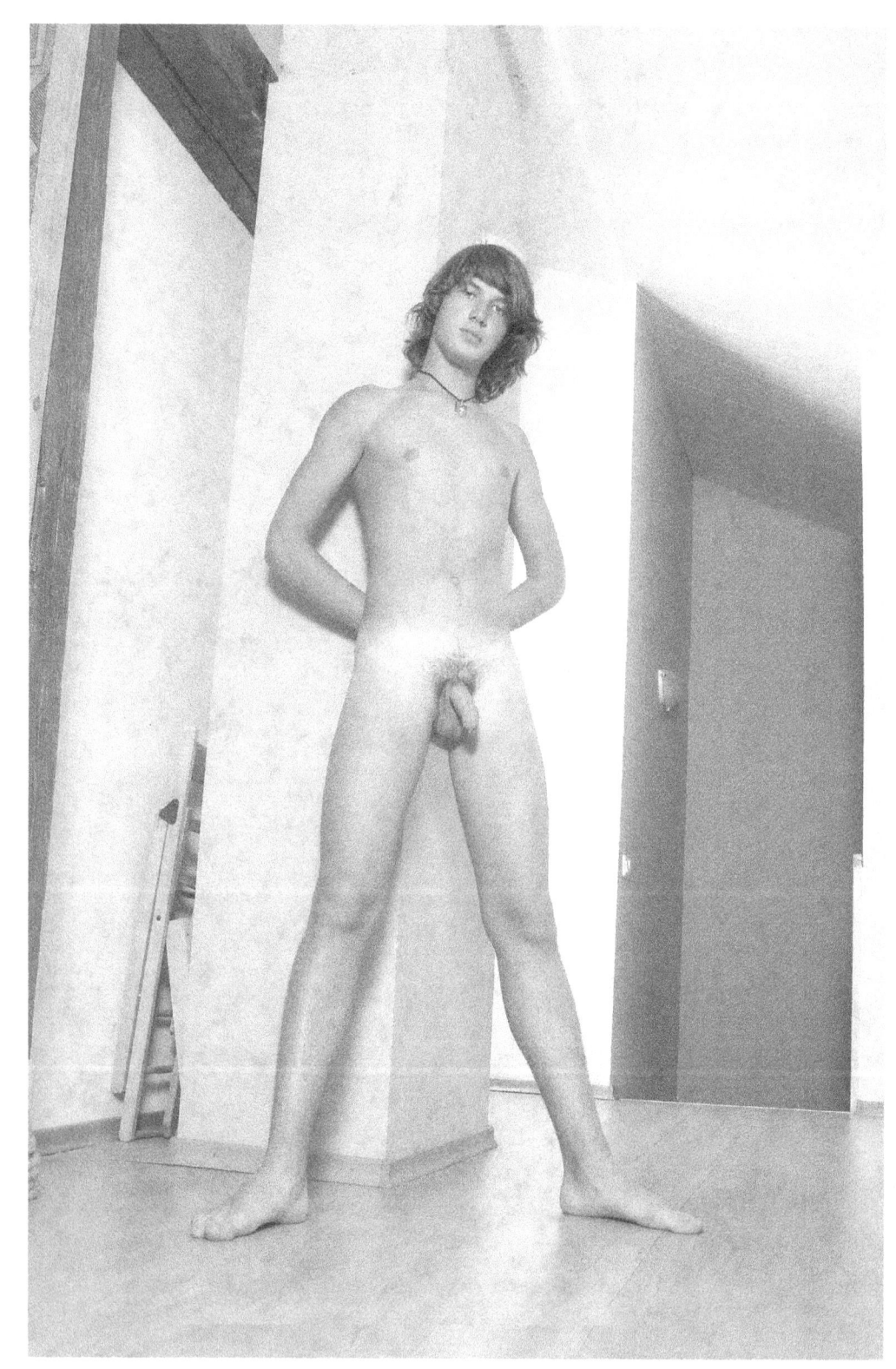

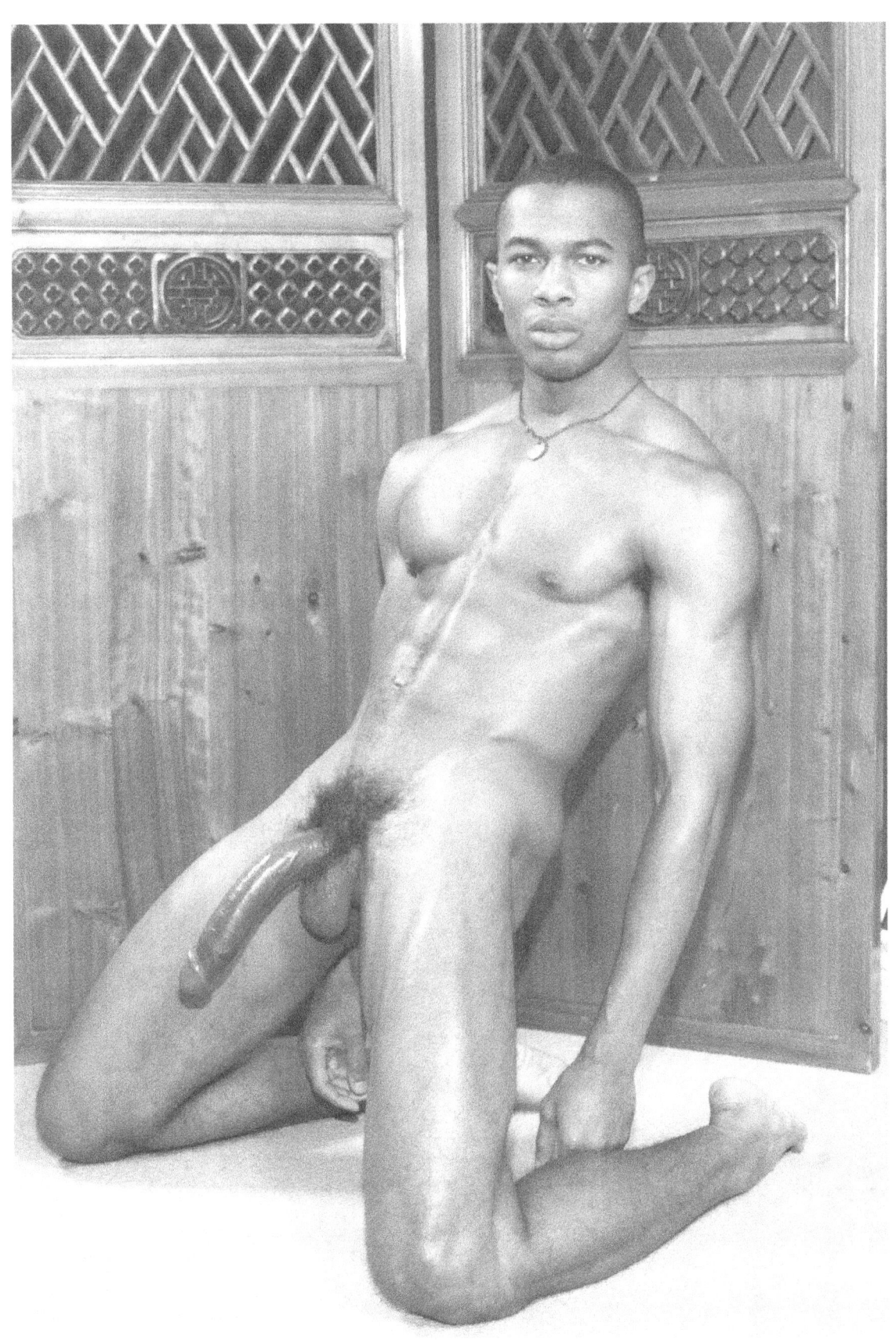

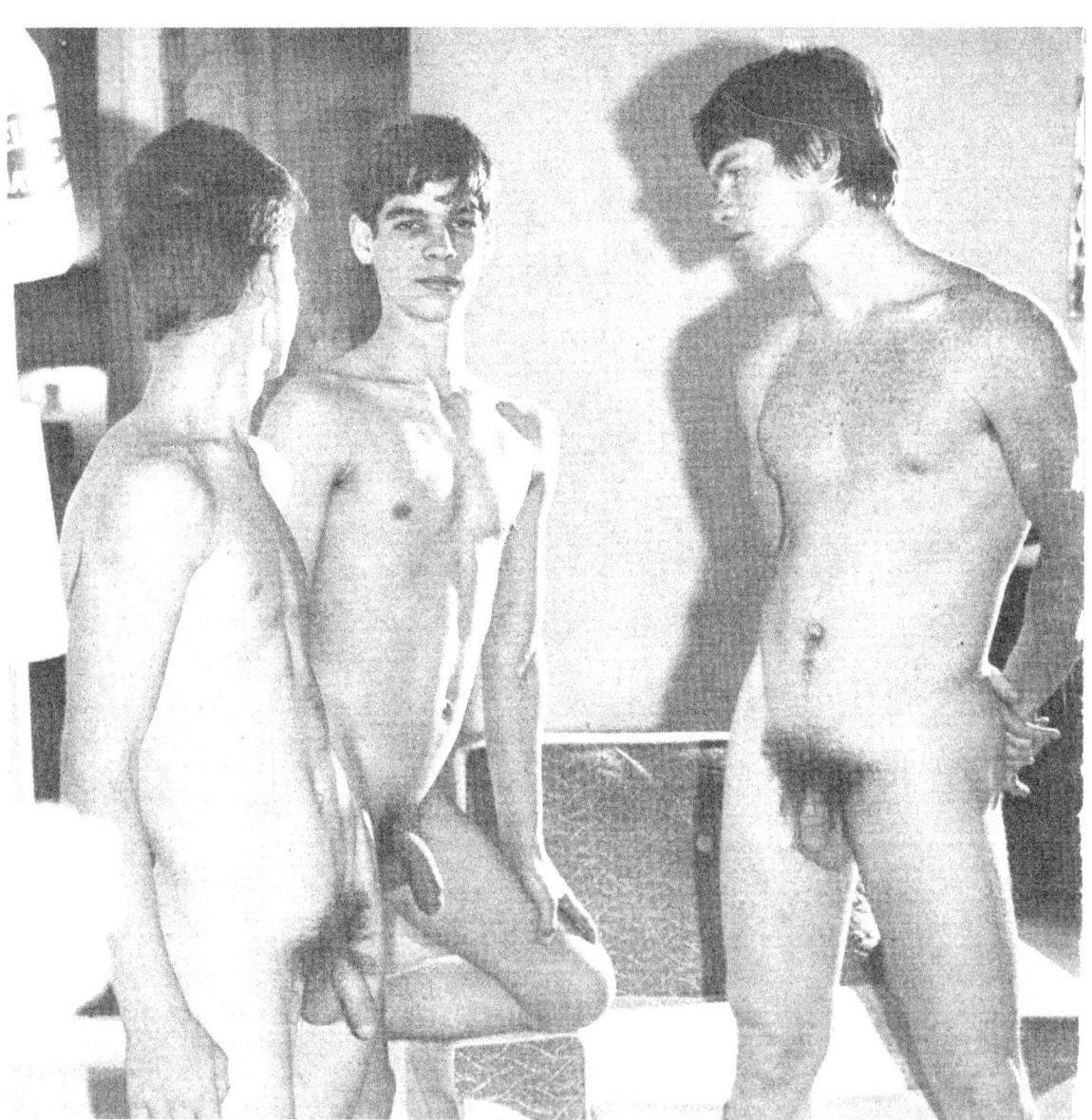

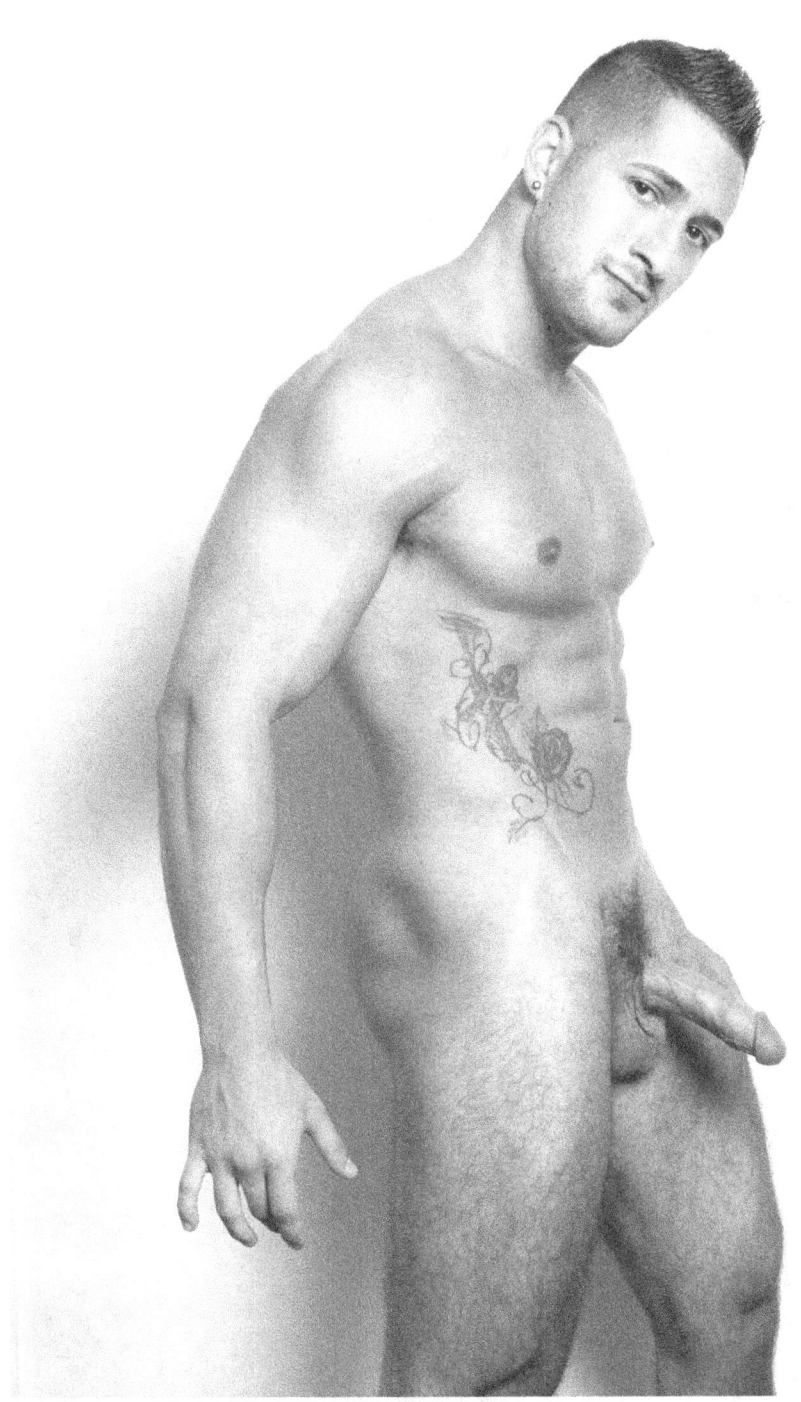

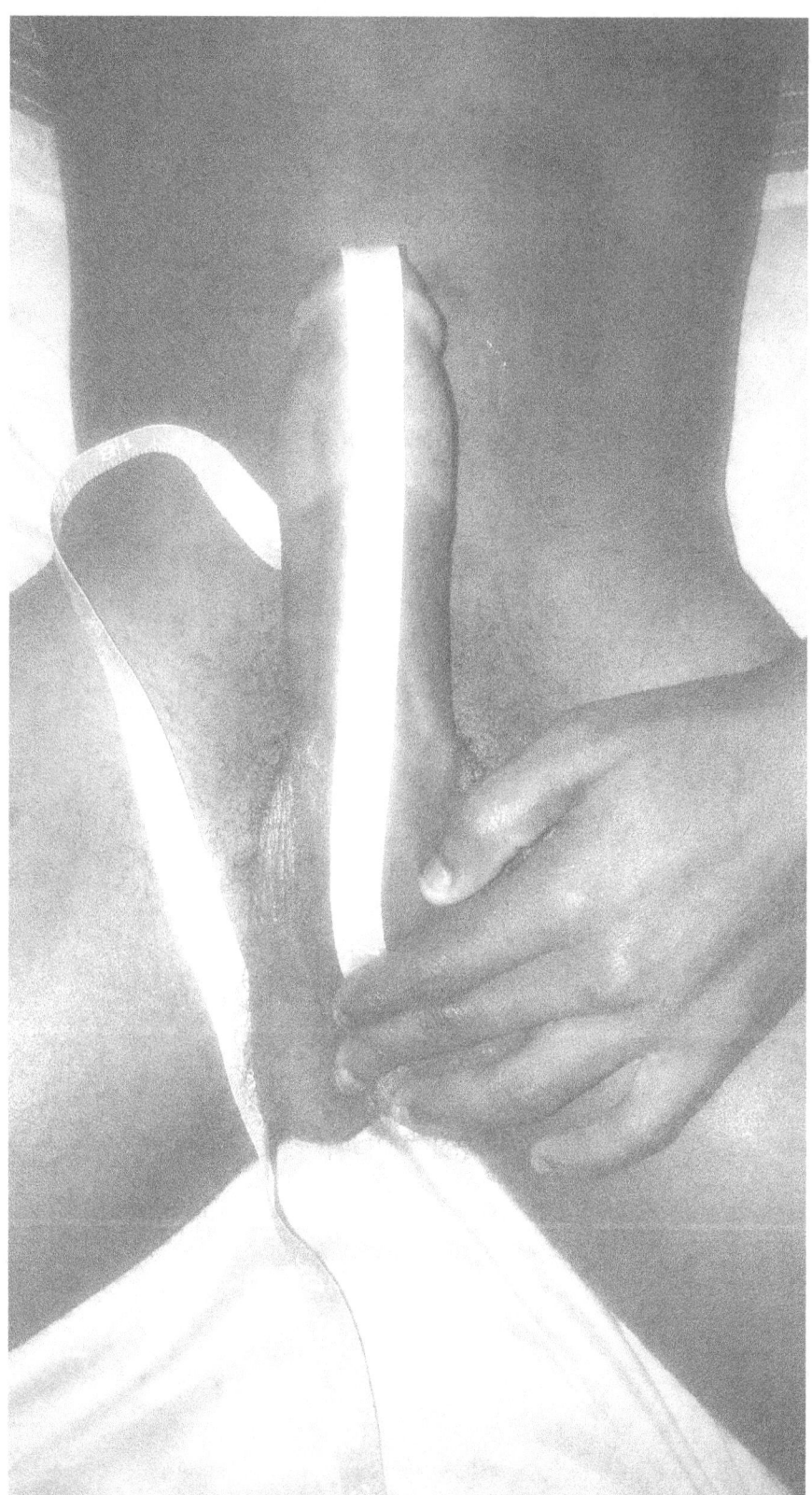

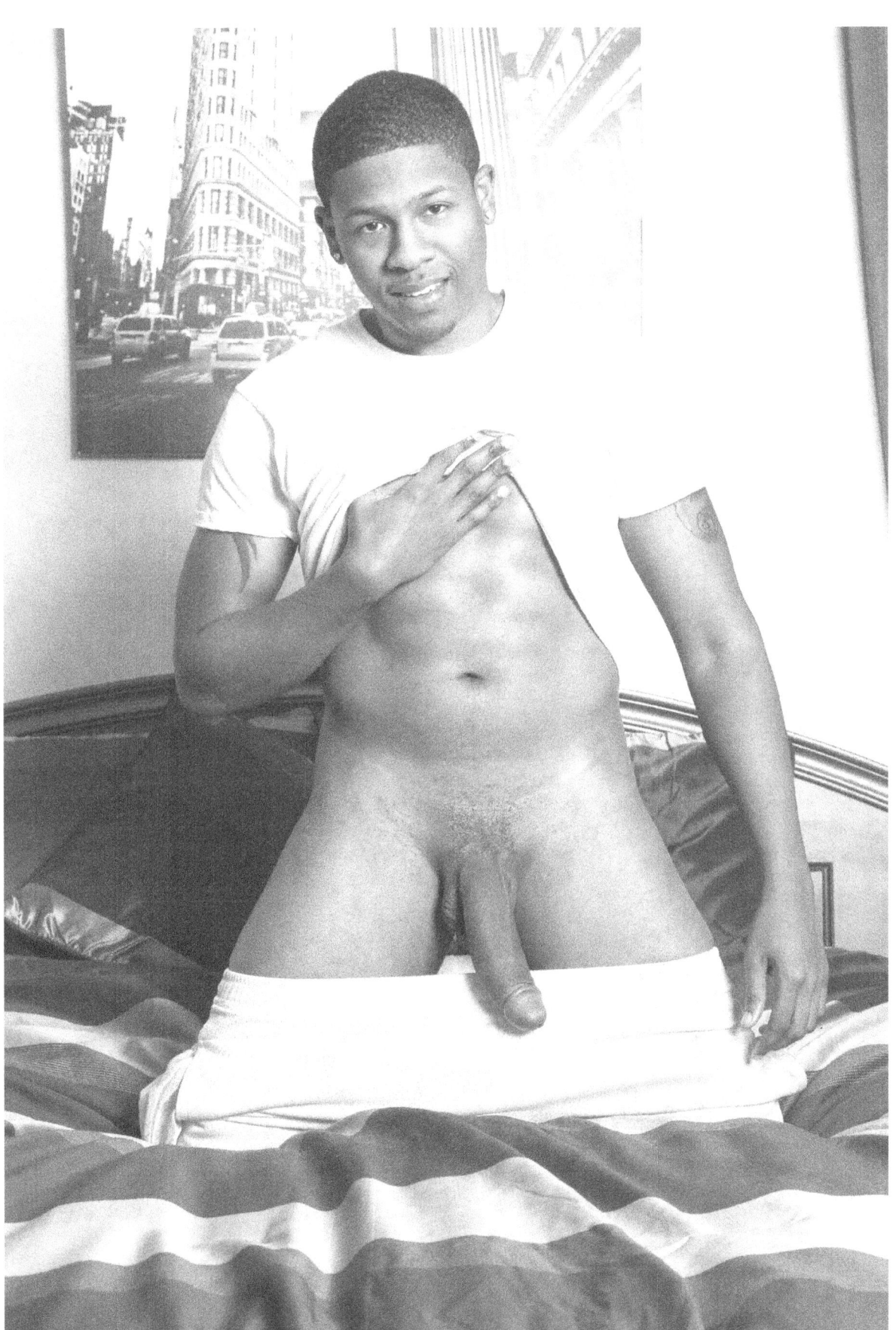

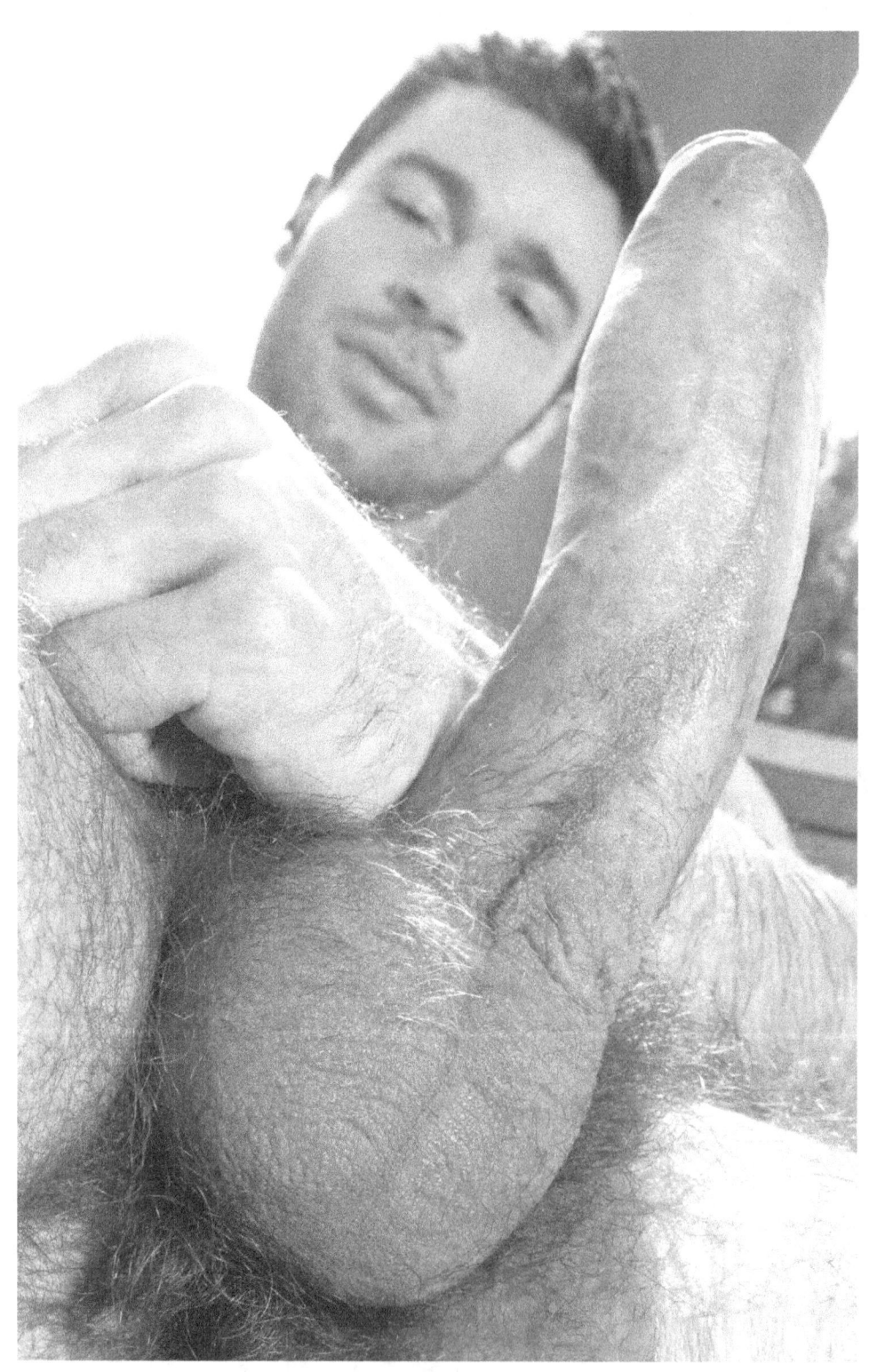

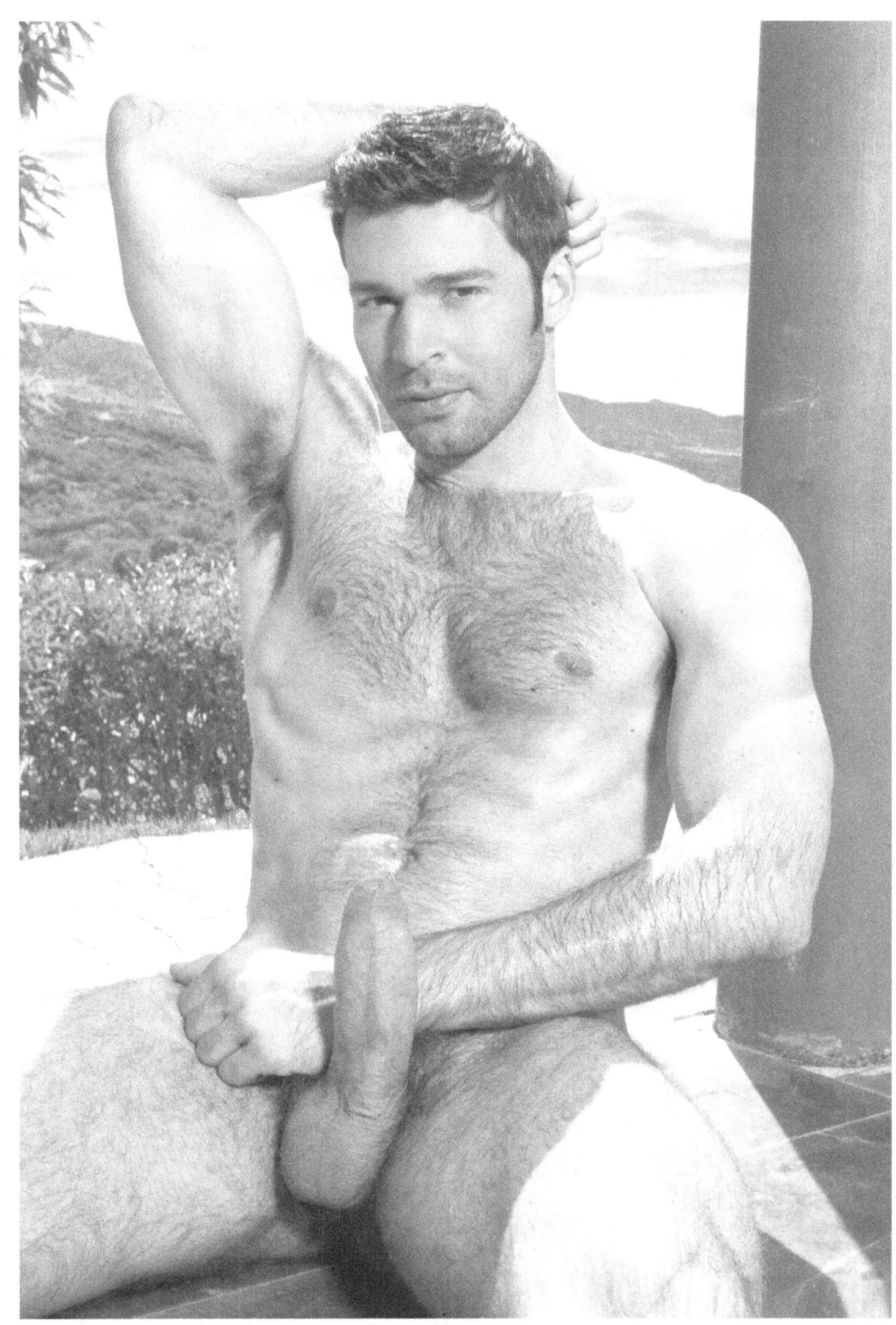

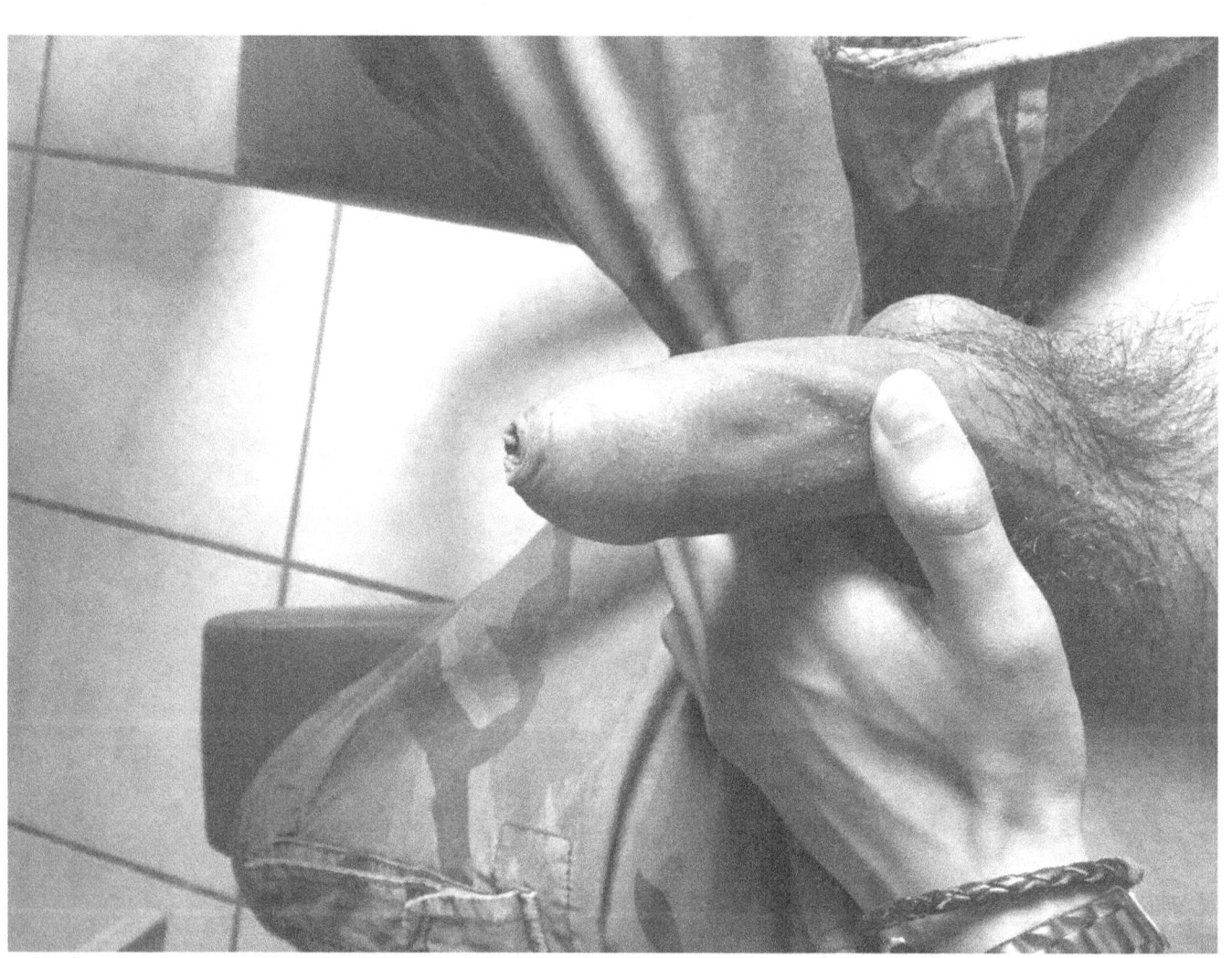

## The Greatest Unrestrained Gay Cities In America:

## Get your freak on Site Poll

West Hollywood gay men who are hoping for a commitment-free hookup have an extra-special reason to celebrate, as their city has been named the most promiscuous U.S. destination in a new poll.
SeekingArrangement.com, which bills itself as the world's largest "sugar daddy" dating website, polled 11,000 of its active gay members on how many join dating websites with casual sex as their main motivation. West Hollywood took the top spot based on how many gay male members responded to having 10 or more sexual partners in the course of a year, followed by Washington, D.C. and San Francisco in second and third place, respectively.
"According to our study, more gay males utilize online dating for 'hooking up' compared to heterosexual males," the site's founder Brandon Wade said in a statement. "While there is always potential to fall in love, online dating makes it very easy to find singles who are similarly looking for something less serious."
Without further ado, check out SeekingArrangement.com's list of top 10 most promiscuous gay cities in America below:

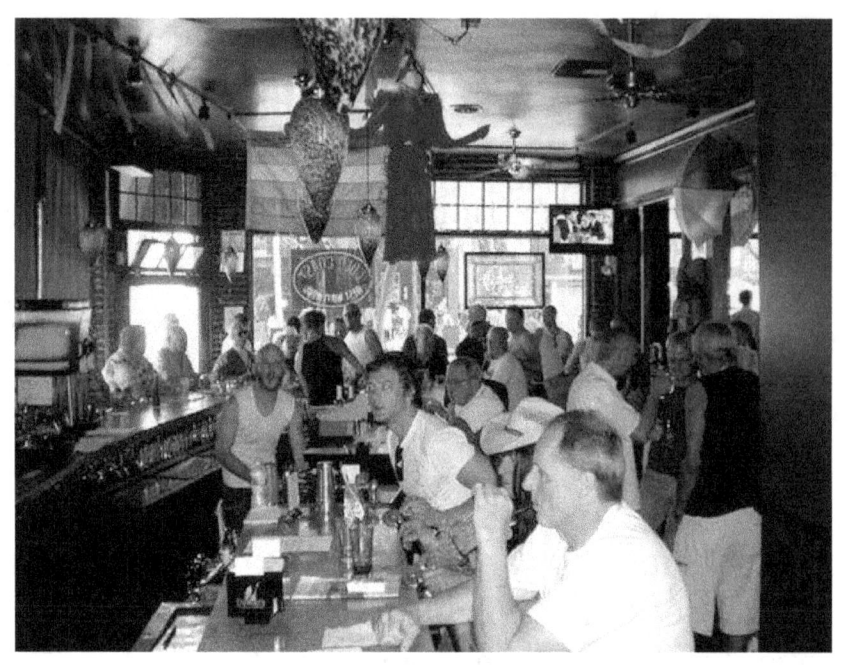

Washington Blade's Best of Gay D.C.

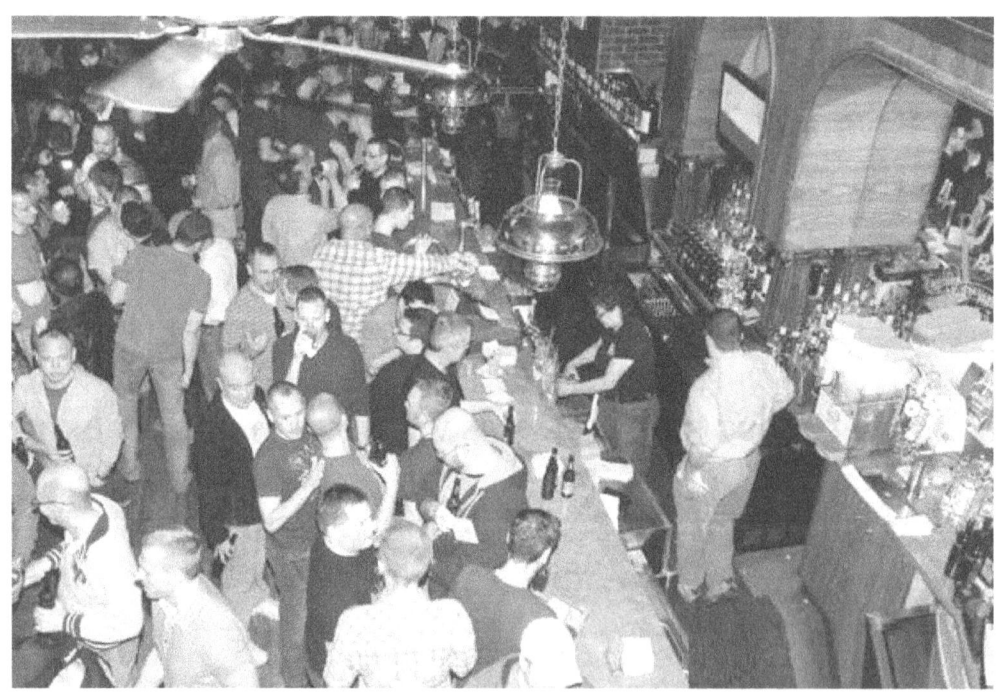

Gay Club in San Francisco

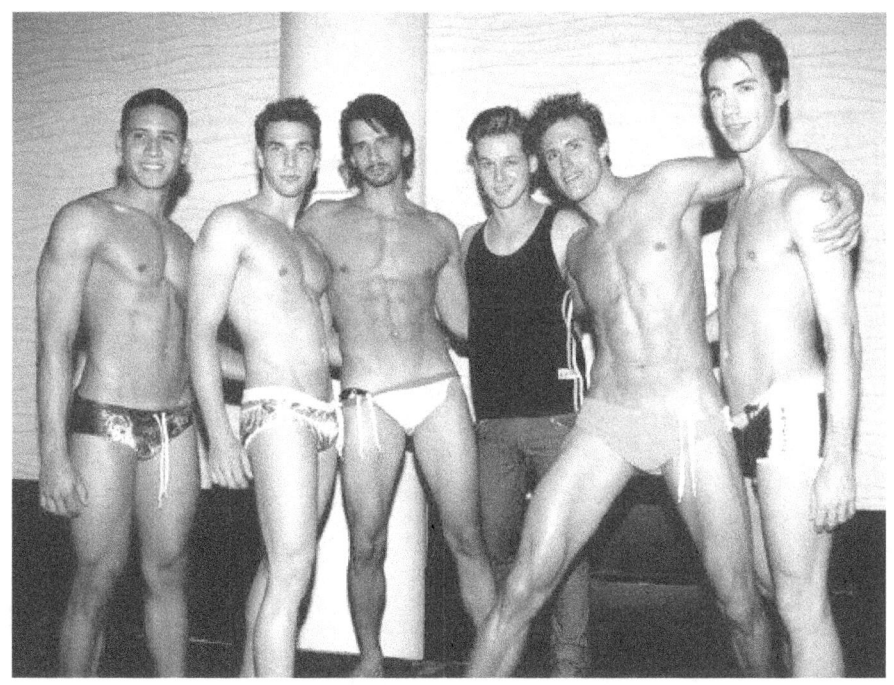

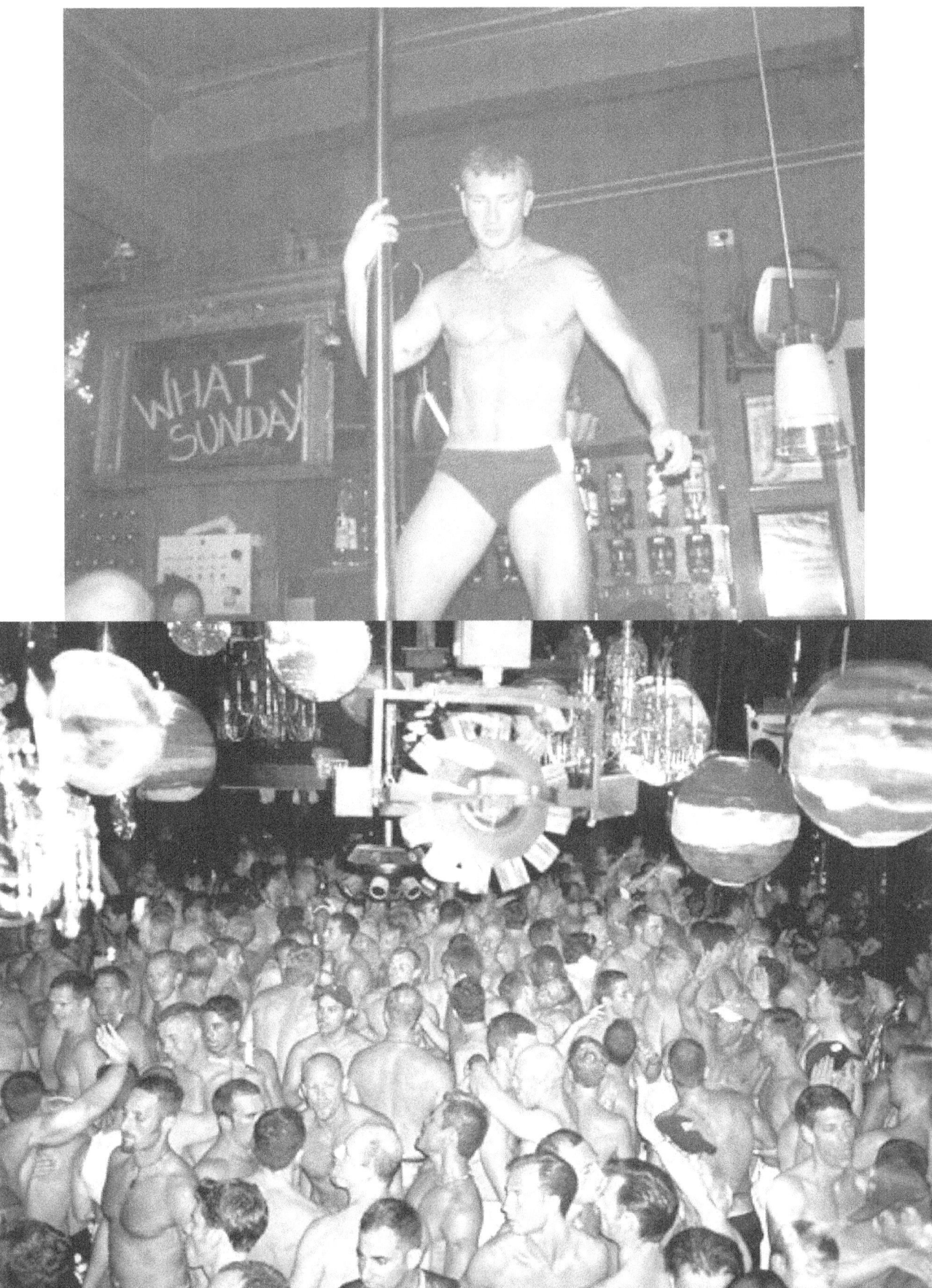

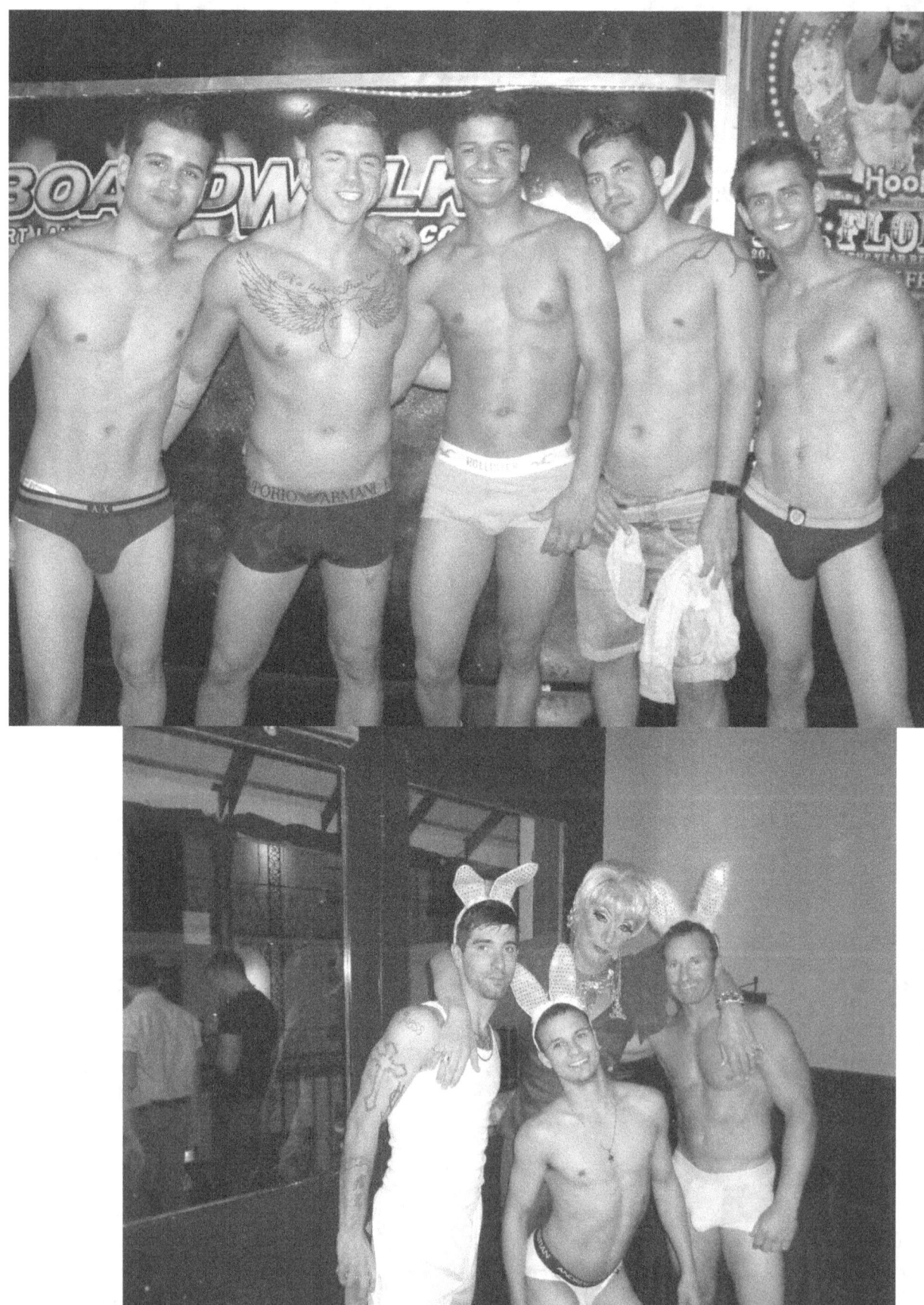

# Best gay bar in NYC

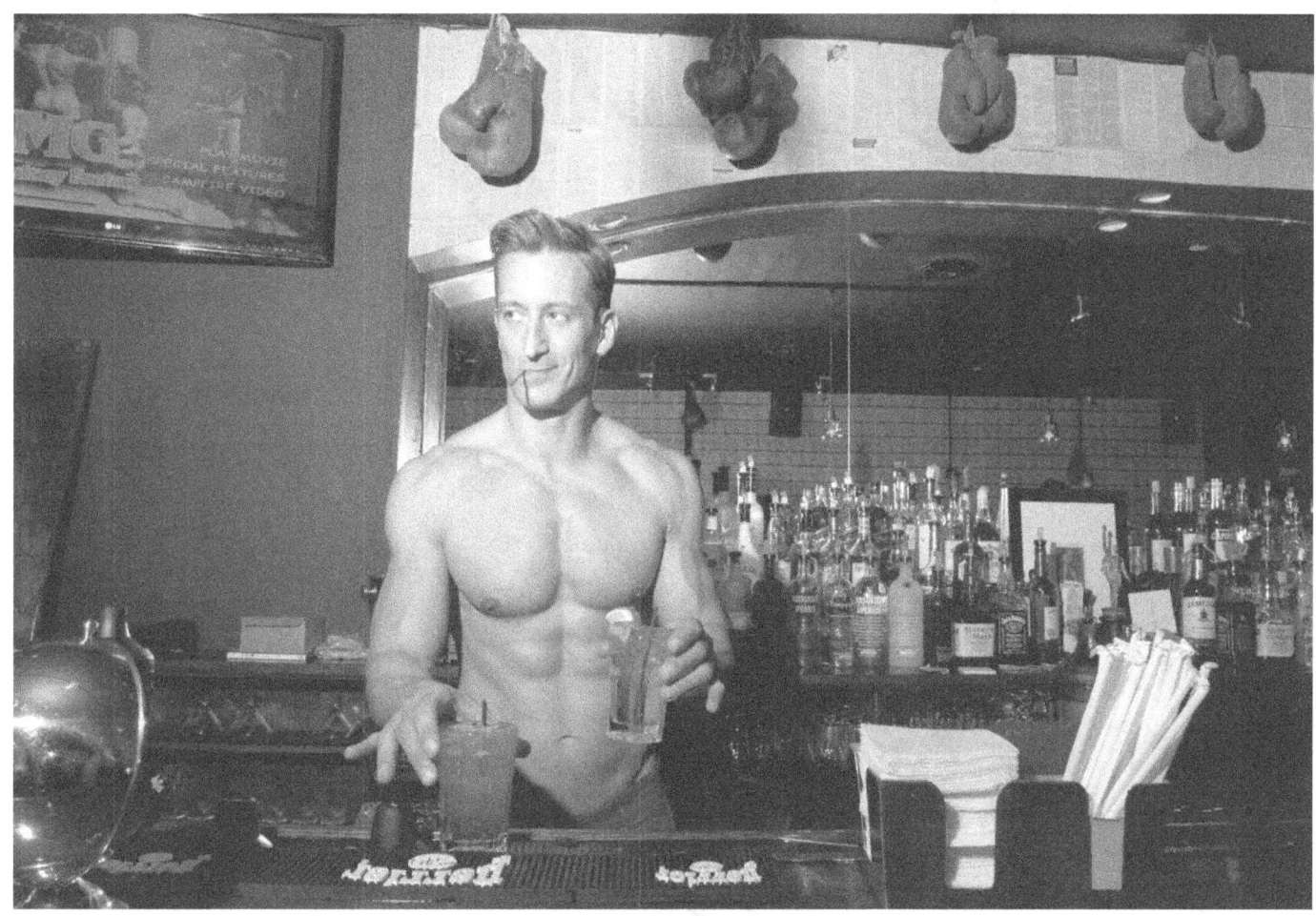

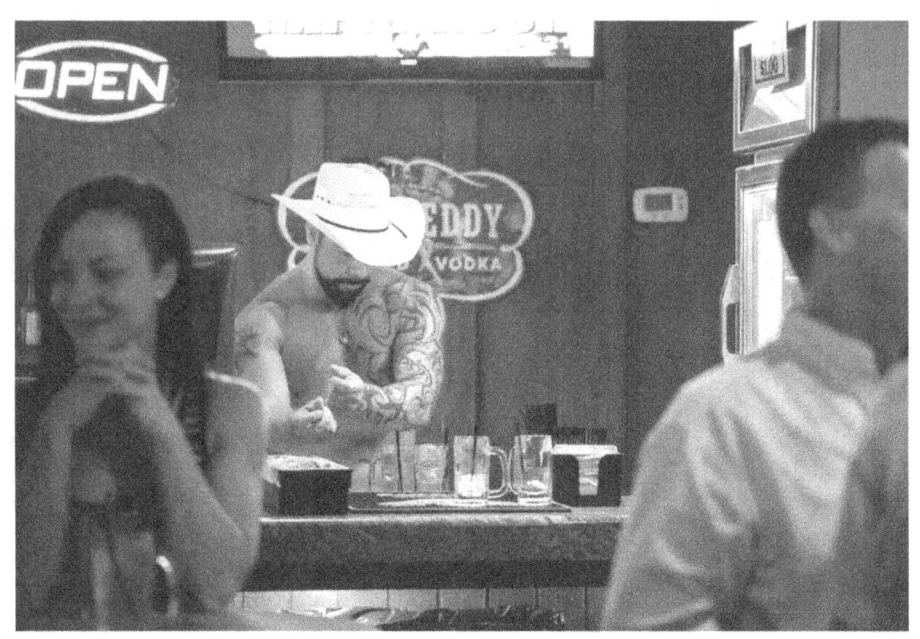
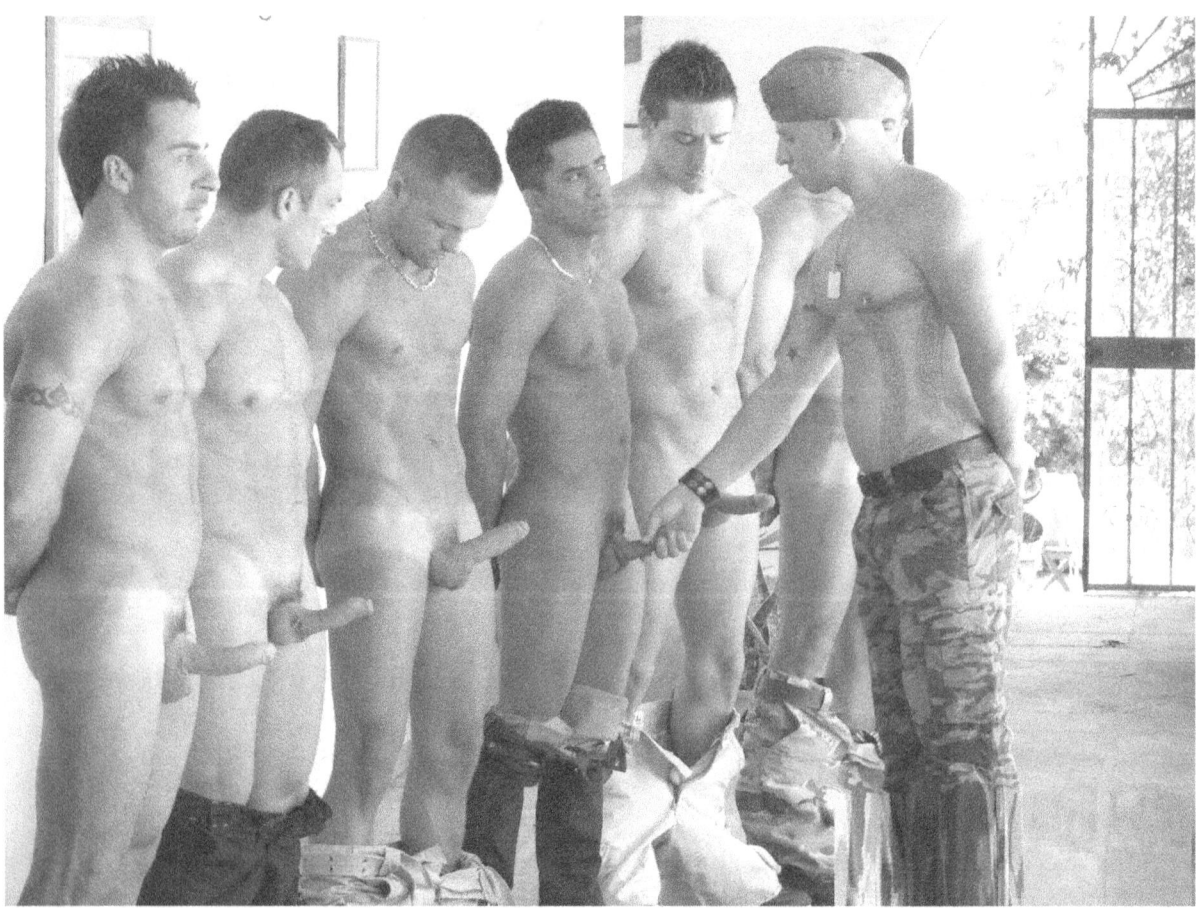

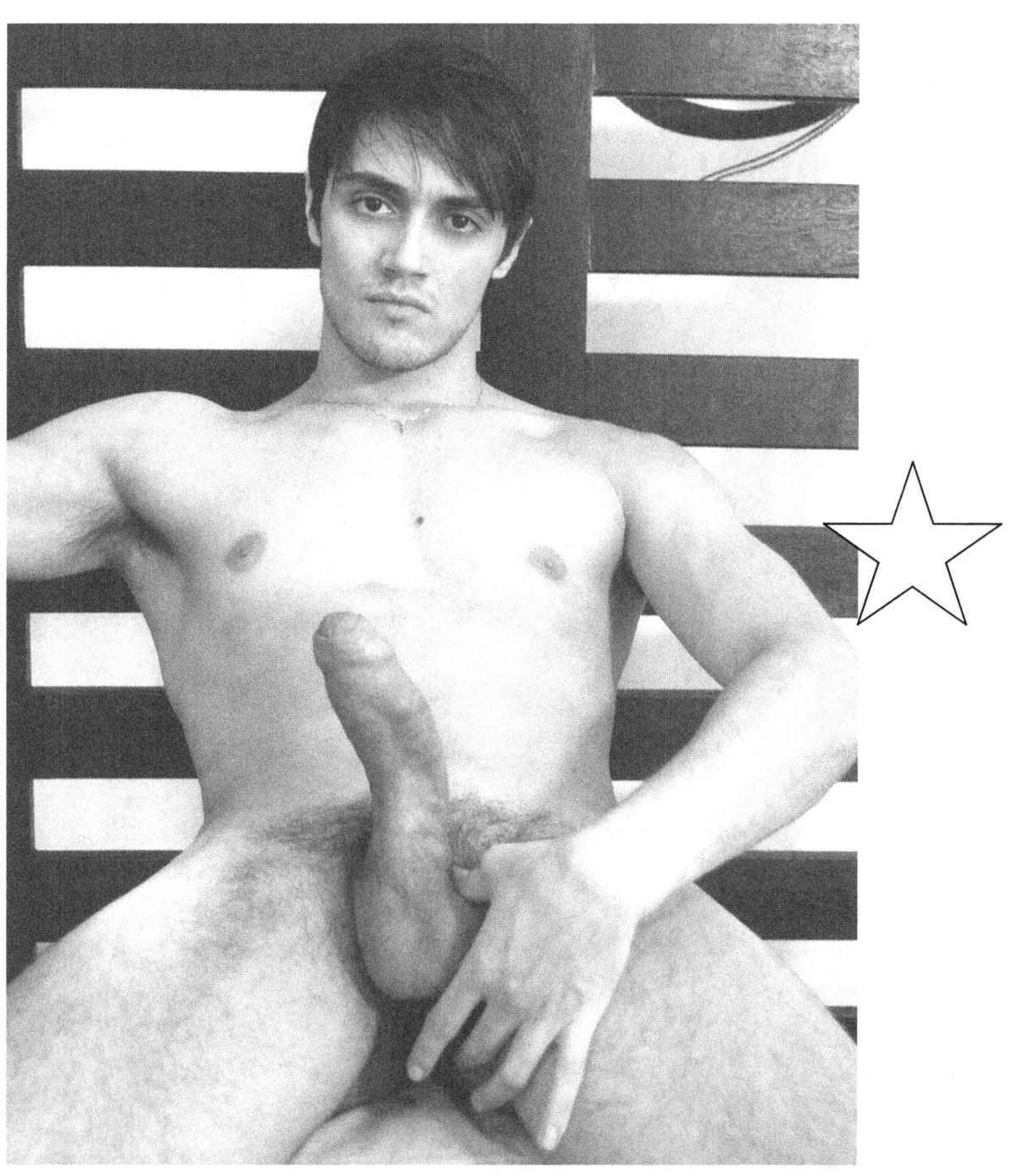

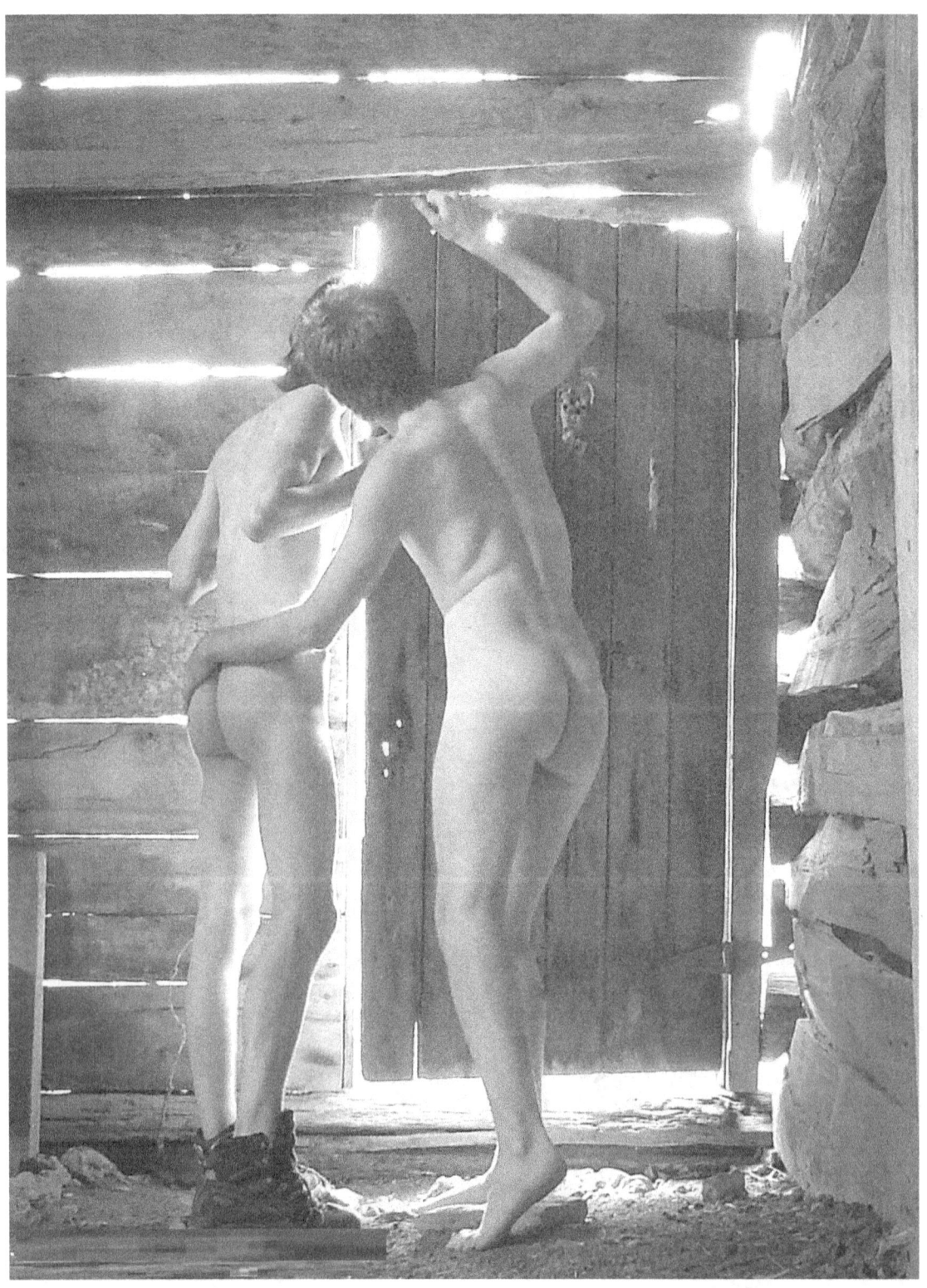

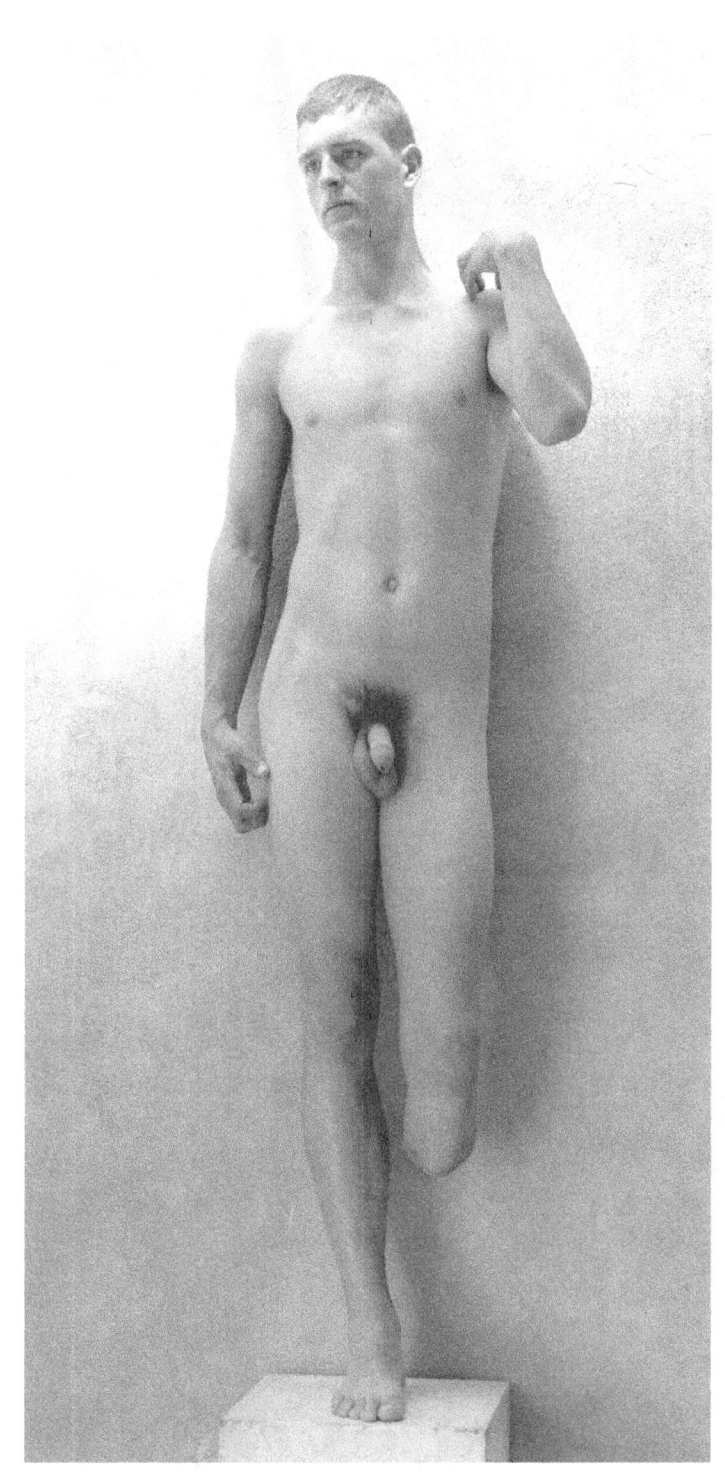

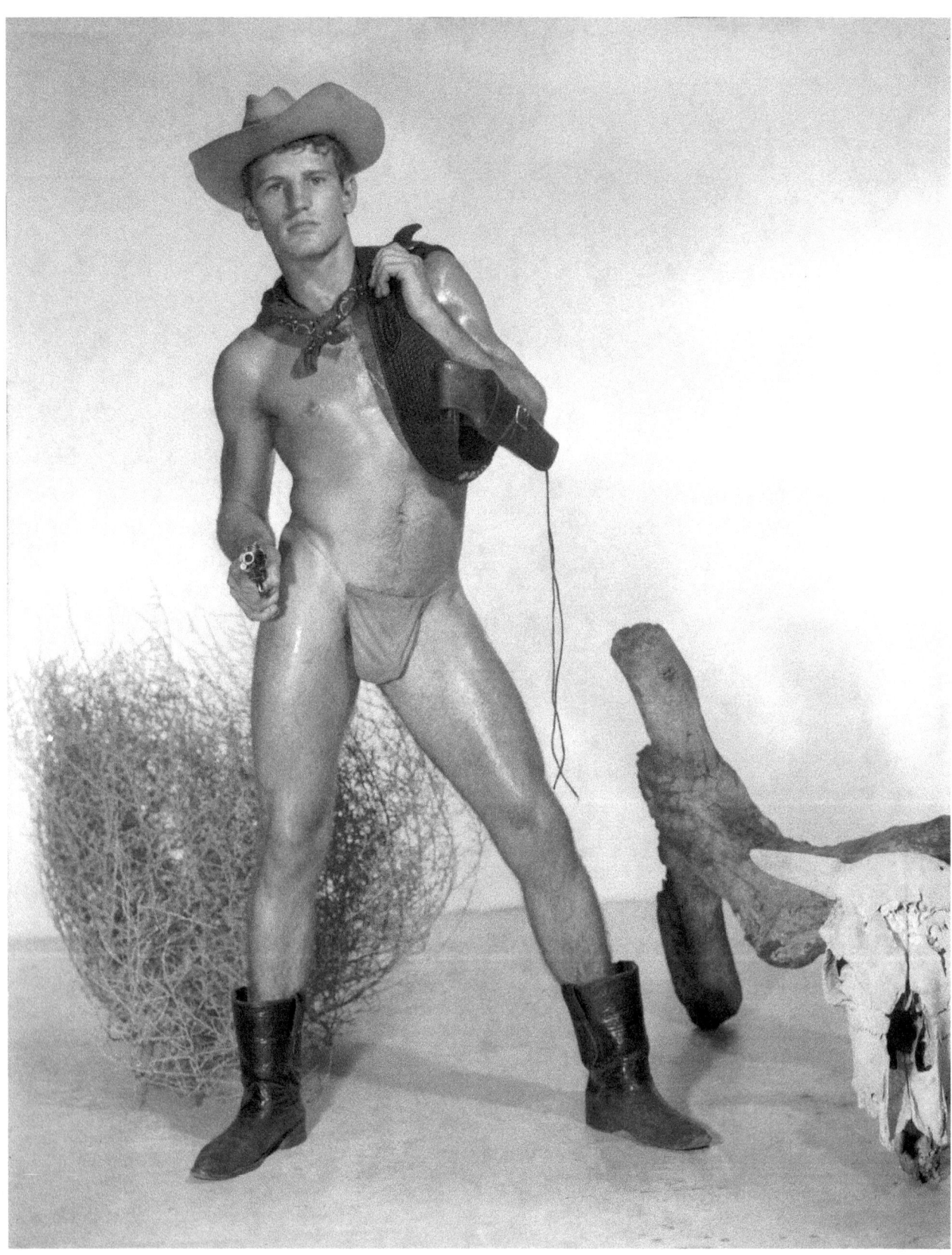

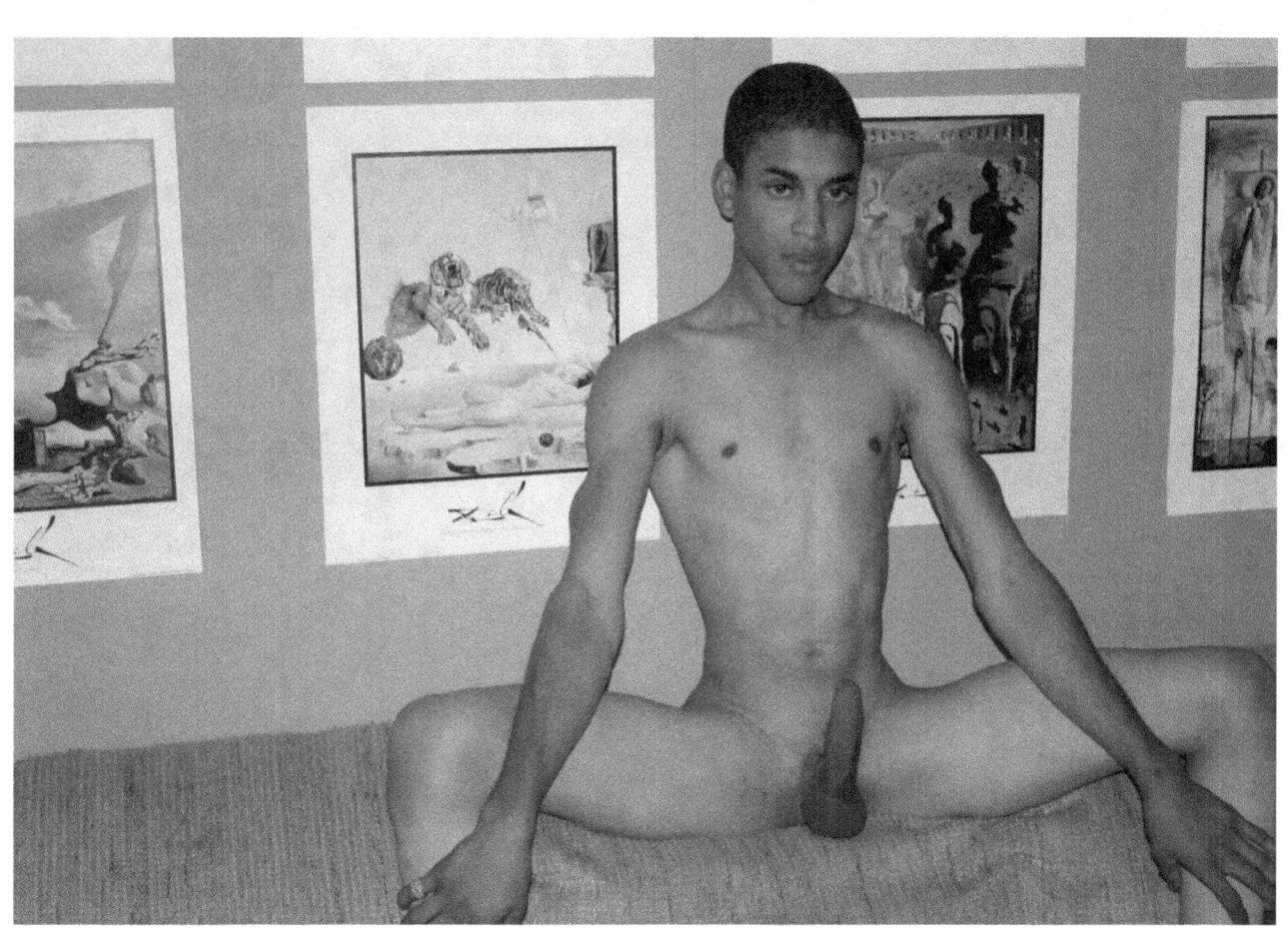

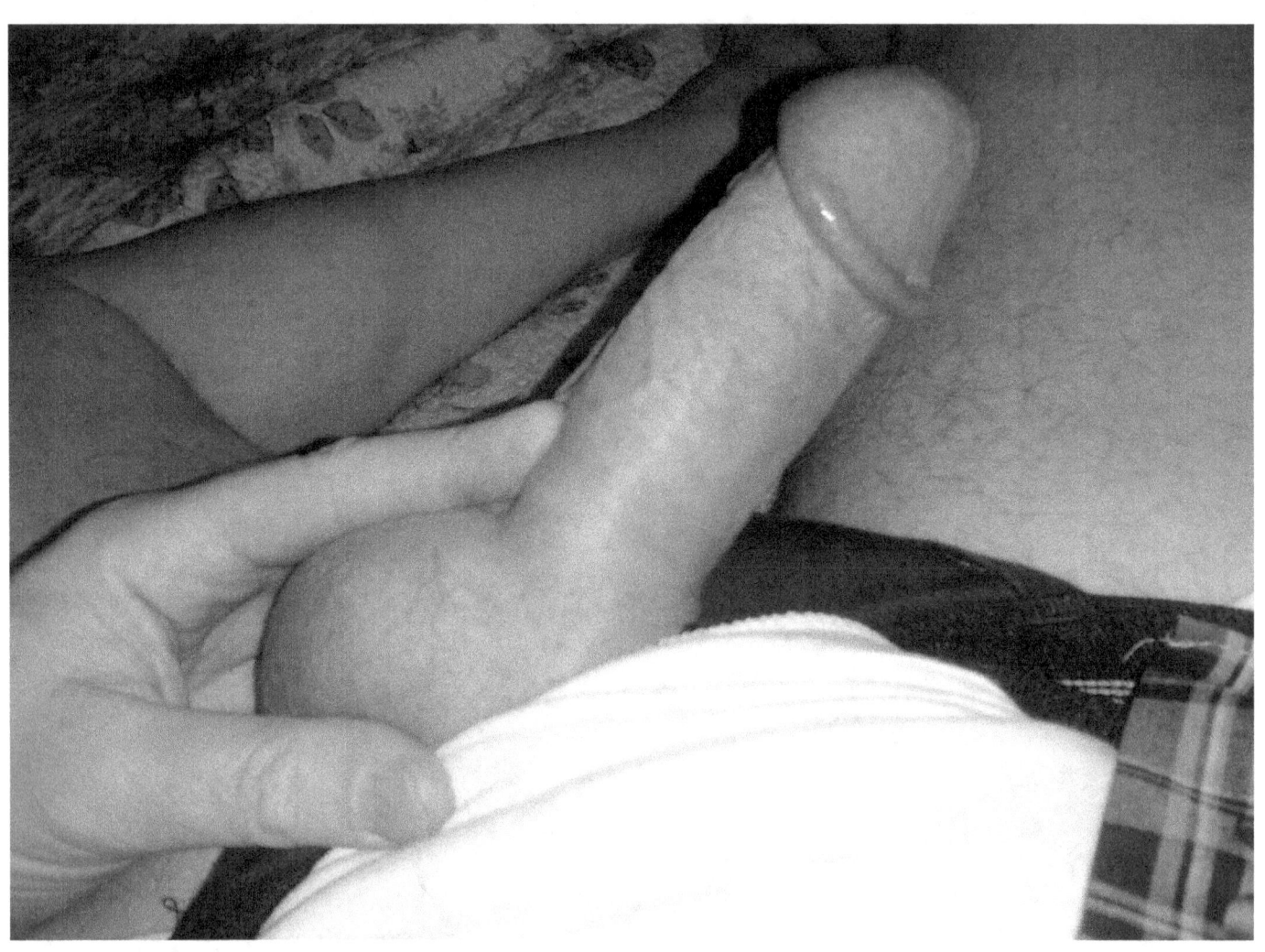

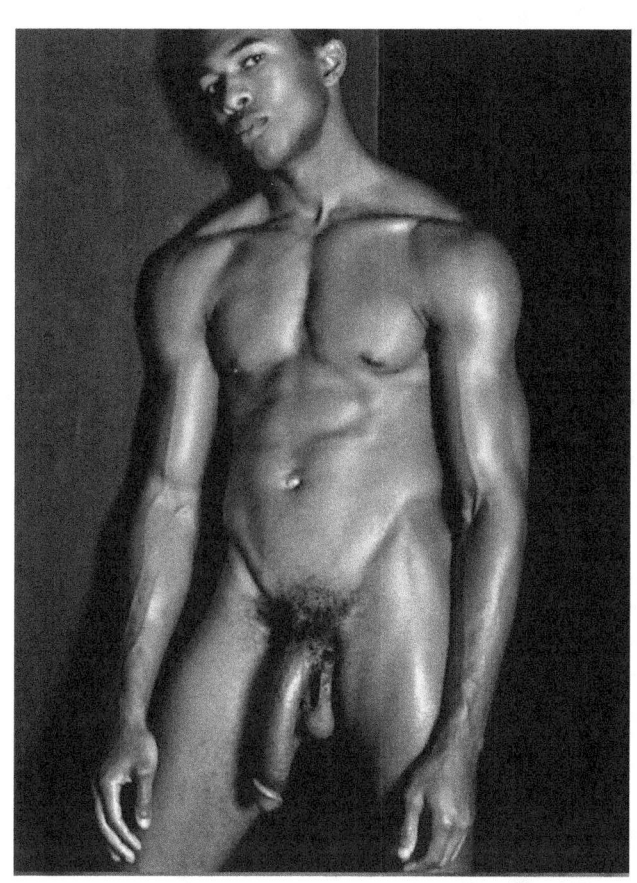

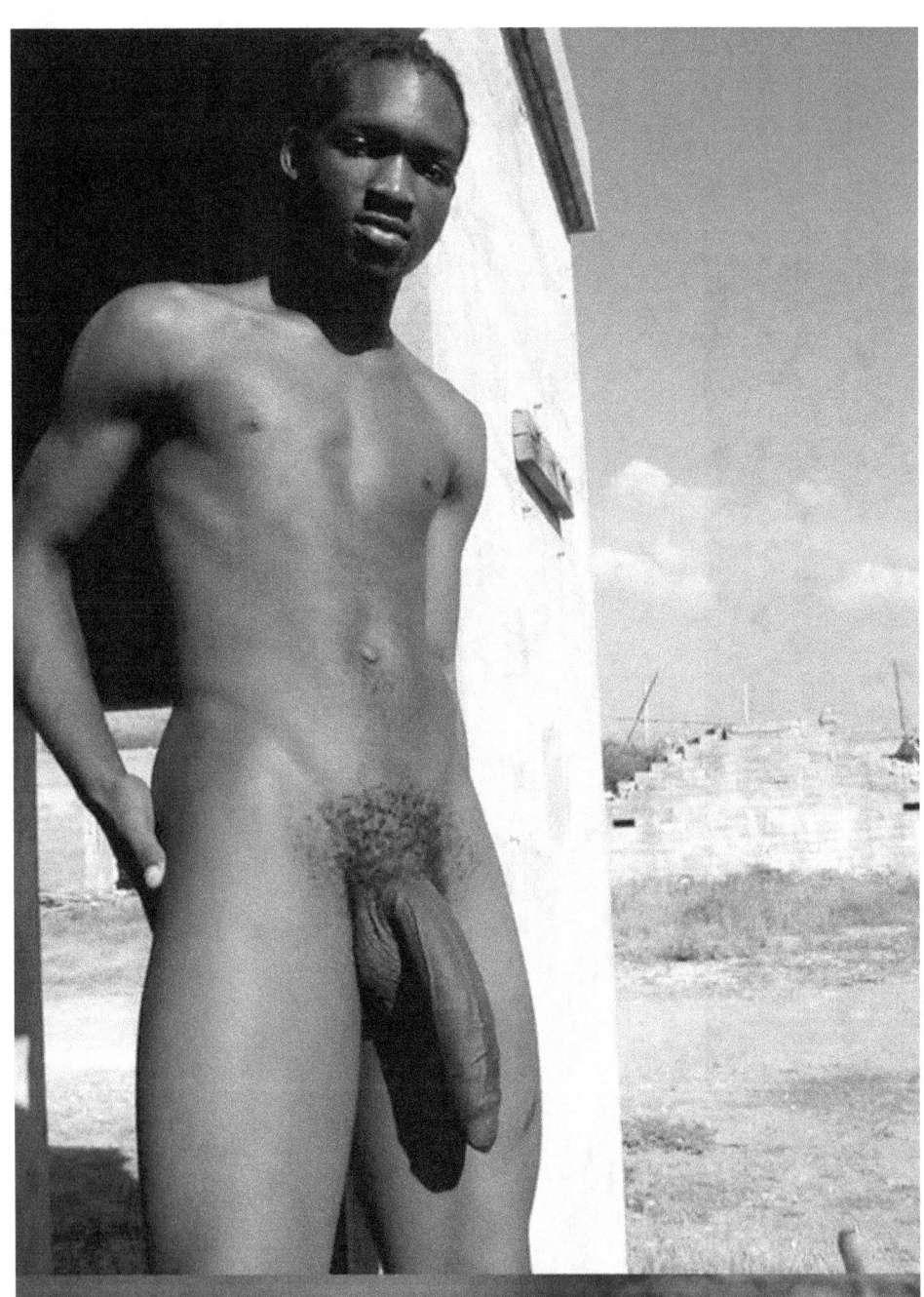

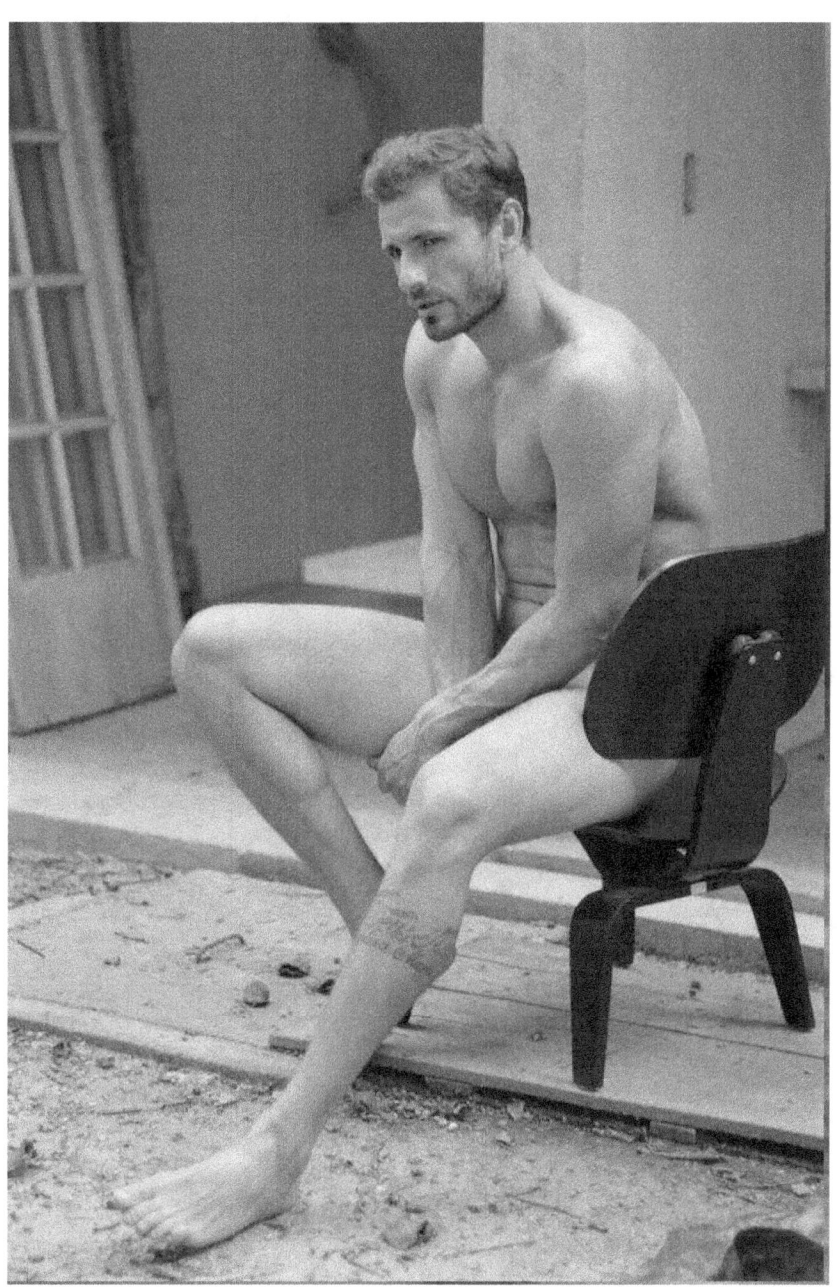

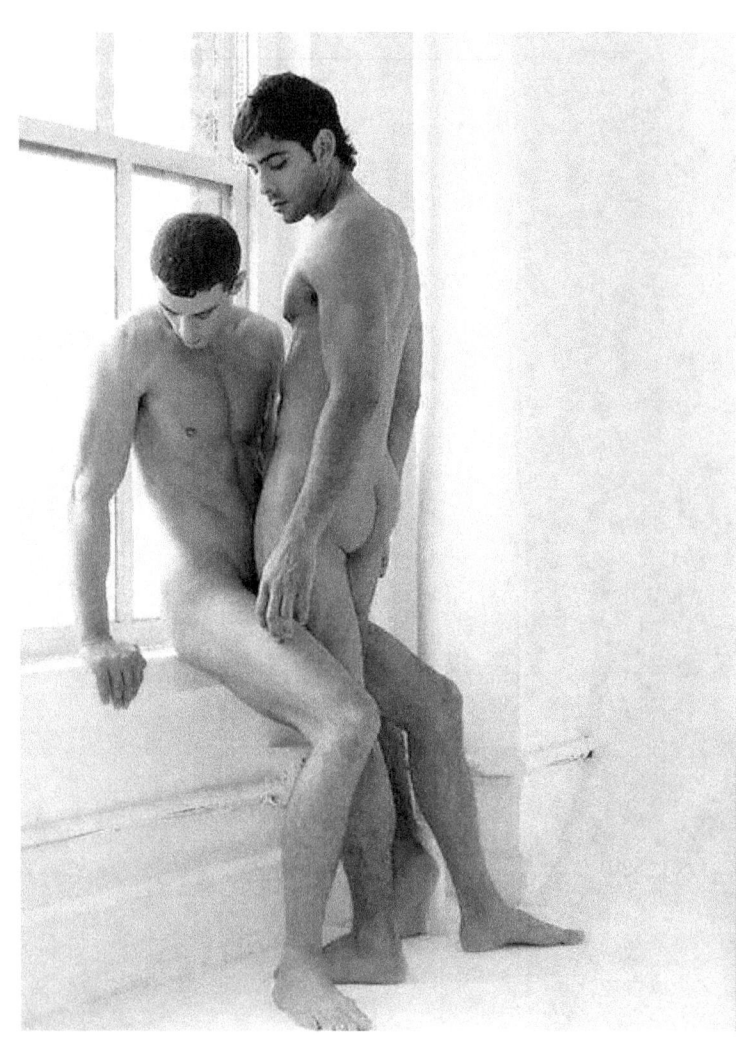
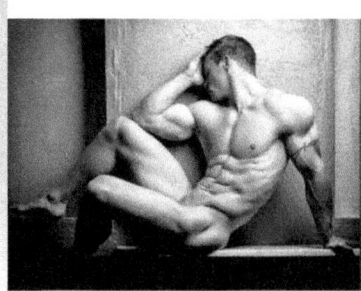

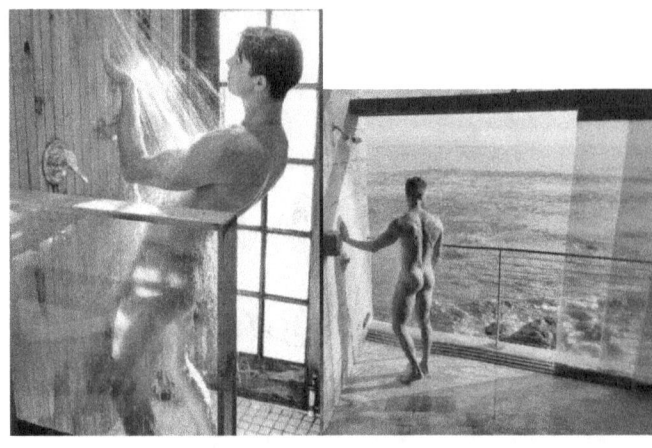

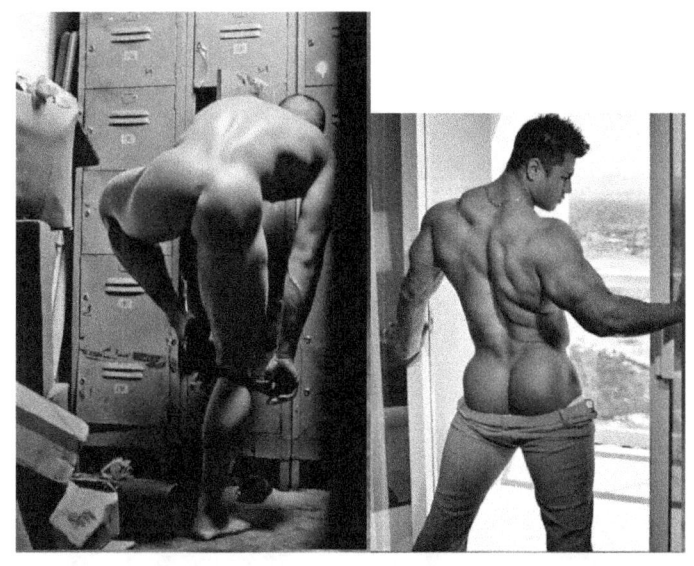
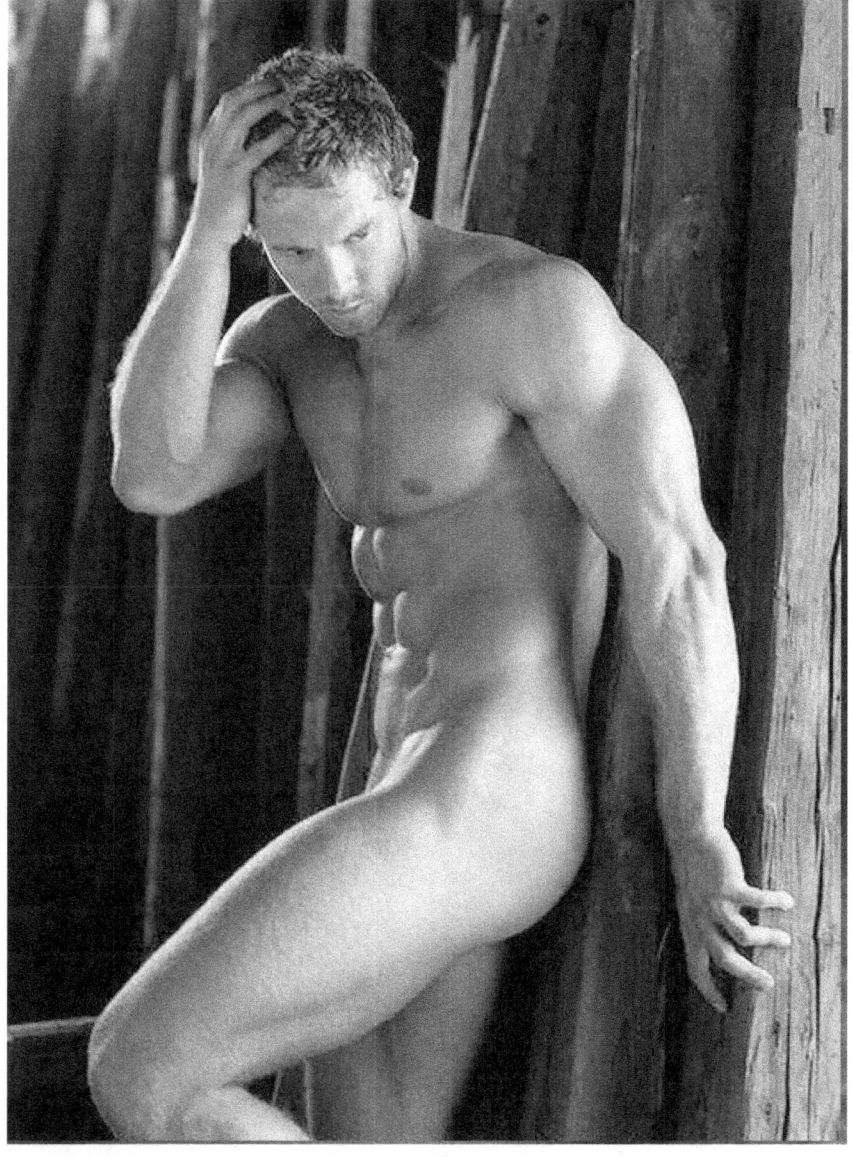

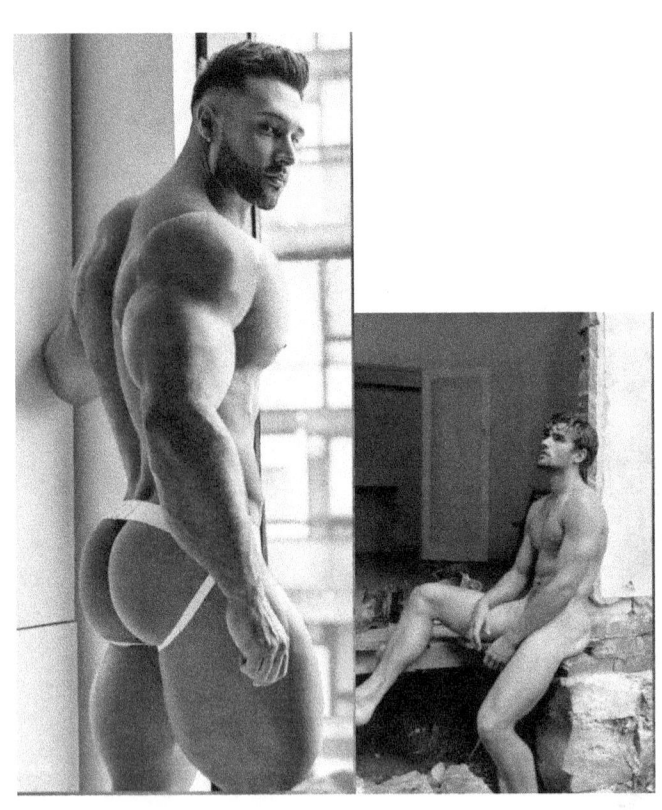
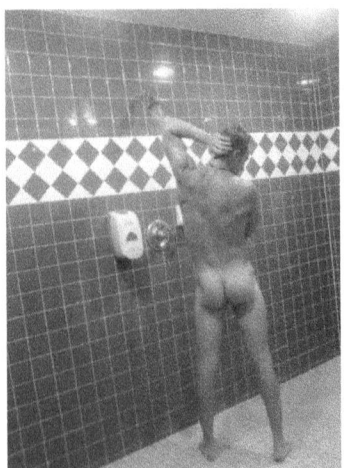

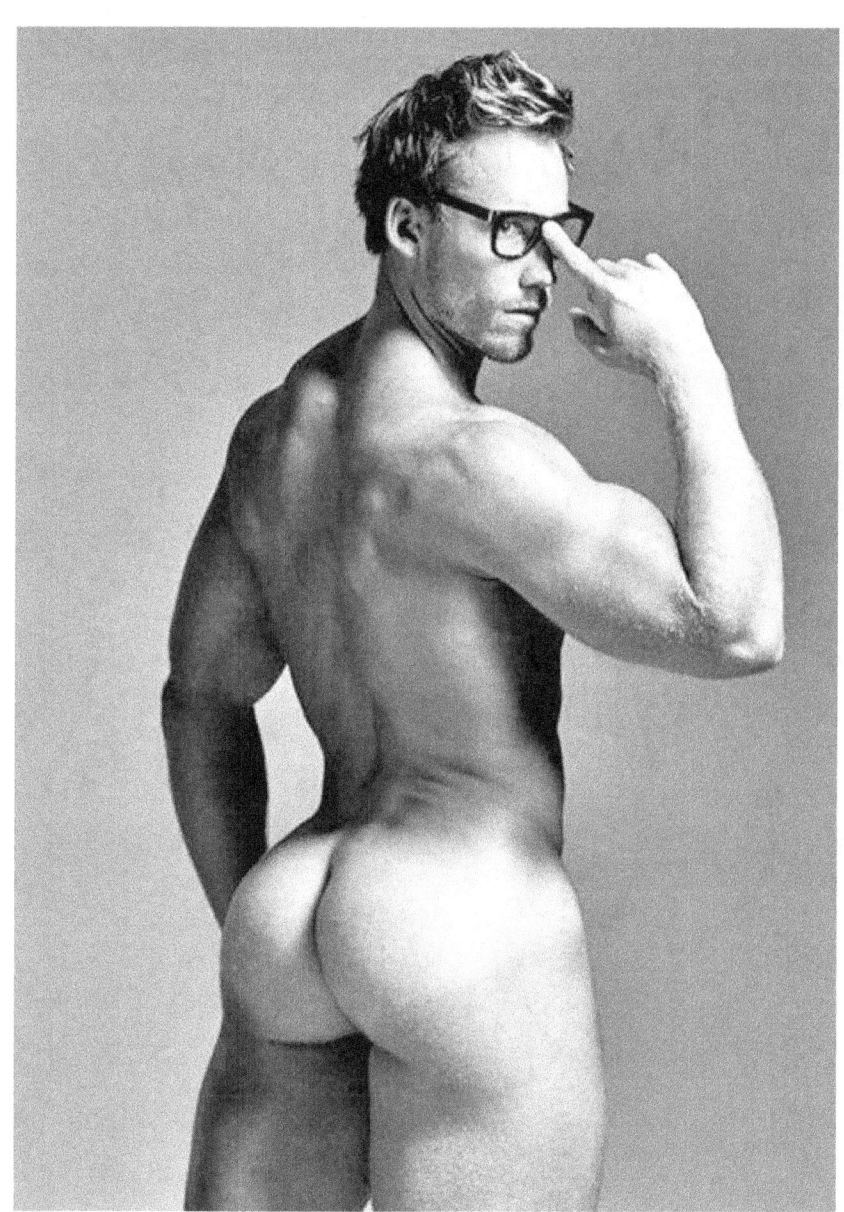

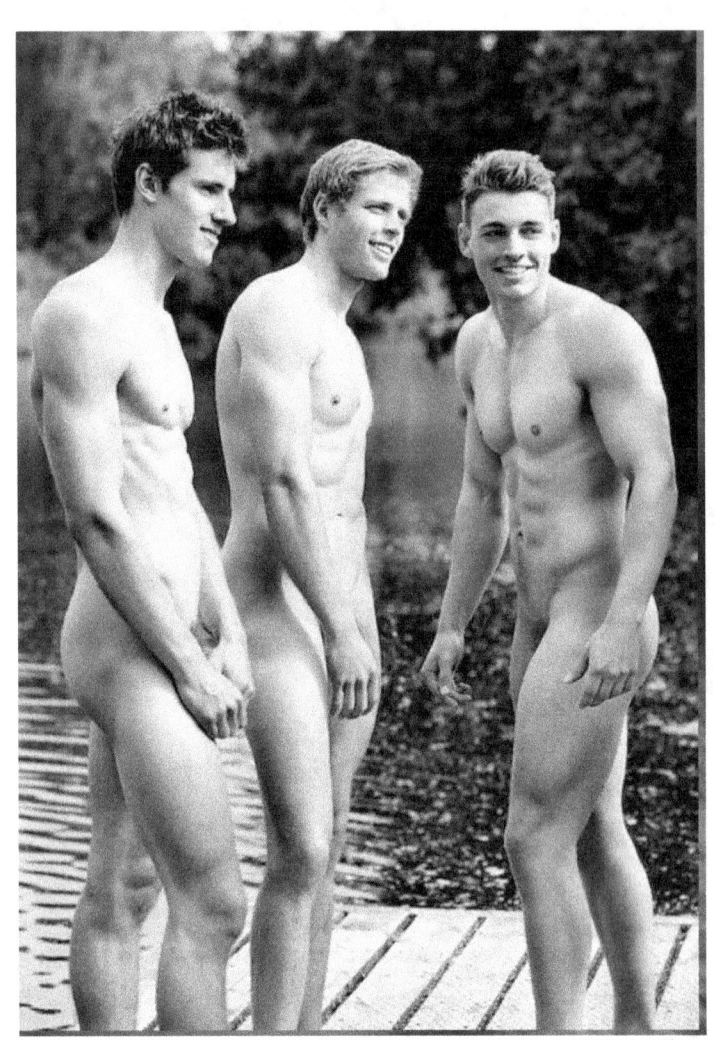

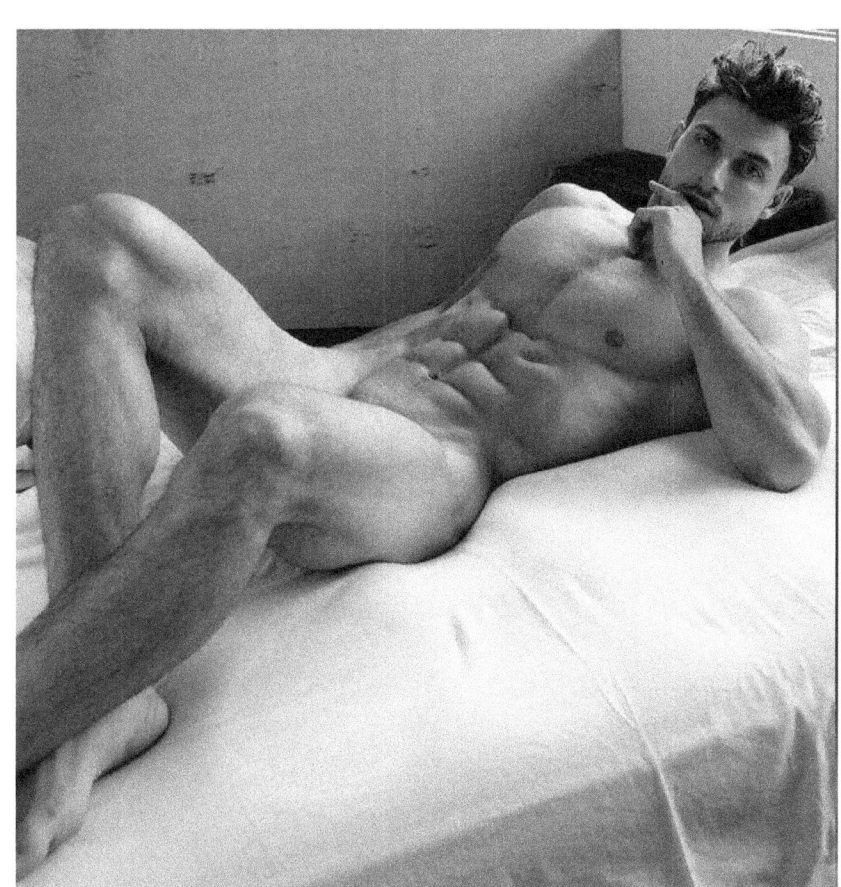

www.ingramcontent.com/pod-product-compliance
Lightning Source LLC
Chambersburg PA
CBHW080945170526
45158CB00008B/2376